A HAUNTED HISTORY OF
DENVER'S
CROKE—PATTERSON MANSION

A HAUNTED HISTORY OF
DENVER'S
CROKE—PATTERSON MANSION

to menzies —
ill try not to be ashamed of
my achievements. :)

— jordan alexander lygett

ANN ALEXANDER LEGGETT + JORDAN ALEXANDER LEGGETT

Haunted
America

Published by Haunted America

A Division of The History Press

Charleston, SC 29403

www.historypress.net

Copyright © 2011 by Ann Alexander Leggett and Jordan Alexander Leggett

All rights reserved

First published 2011

Manufactured in the United States

ISBN 978.1.60949.312.7

Library of Congress Cataloging-in-Publication Data

Leggett, Ann Alexander.
A Haunted History of Denver's Croke-Patterson Mansion / Ann Alexander Leggett and
Jordan Alexander Leggett.
p. cm.
Includes bibliographical references.
ISBN 978-1-60949-312-7
1. Haunted houses--Colorado--Denver. 2. Croke-Patterson-Campbell Mansion (Denver,
Colo.) I. Leggett, Jordan Alexander. II. Title.
BF1472.U6L444 2011
133.1'2978883--dc23
2011028514

For Sara and Tom: thanks for the literary gene. We love you.

All houses wherein men have lived and died
Are haunted houses. Through the open doors
The harmless phantoms on their errands glide,
With feet that make no sound upon the floors.

We meet them at the door-way, on the stair,
Along the passages they come and go,
Impalpable impressions on the air,
A sense of something moving to and fro.

There are more guests at table, than the hosts
Invited; the illuminated hall
Is thronged with quiet, inoffensive ghosts,
As silent as the pictures on the wall.

We have no title-deeds to house or lands;
Owners and occupants of earlier dates
From graves forgotten stretch their dusty hands,
And hold in mortmain still their old estates.

So from the world of spirits there descends
A bridge of light, connecting it with this,
O'er whose unsteady floor, that sways and bends,
Wander our thoughts above the dark abyss.

—From the poem "Haunted Houses," by Henry Wadsworth Longfellow

CONTENTS

Foreword, by Jack Hanley 11
Acknowledgements 15
Introduction 17

And So It Begins 19
What Lies Beneath 27
The Renaissance Man 37
The House on the Hill 43
Babies in the Basement 51
A Good Trade 61
Something Wicked This Way Comes 73
The Good Doctor 85
The Rubber Alligator 93
A Scientific Approach 101
Ghostly Encounters 109
Whispers in the Night 123
A Lonely House No More 129

Appendix: Building Floor Plans 131
Bibliography 137
About the Authors 141

FOREWORD

While yet a boy I sought for ghosts, and sped
Through many a listening chamber, cave and ruin,
And starlight wood, with fearful steps pursuing
Hopes of high talk with the departed dead.
—Percy Bysshe Shelley, "Hymn to Intellectual Beauty"

The pursuit of shadows has been with us from the beginning. In Gallup's most recent assessment of the role of the paranormal in the human consciousness, nearly 75 percent of Americans professed to have experienced a paranormal event; additionally, close to 40 percent expressed a belief in haunted houses. From every aspect of the human experience, our storytelling traditions have included manifestations to express our fears of the unknown. As a folklorist, I have remained fascinated by such cultural constructions and the way in which, over time, we transmit them. Urban legends, folktales, ghost stories: they all represent the dynamic social interactions between us in the transmission of our folk culture. The collection and preservation of ghost stories serves not only to thrill and terrify on the individual level; their transmission remains a vital and important folkloric legacy of the reflection of a society's collective fears.

Since mankind first began to construct grandiose locales, we have stocked them with our most fantastic nightmares. As early as the first century, the Roman historian Plutarch chronicled the haunting of the great Chaeronean baths by the supposed ghost of a murdered man, whose agonizing

shrieks permeated the darkness and forced the closing of the baths by the frightened citizenry. As the polls demonstrate nearly two thousand years later, the ghost story remains as popular as ever. Who cannot recall from childhood the hurried pace as one walked passed a particular house, local bridge or geographical oddity that was never to be visited after sundown? The association of specific locations with evil is, for better or worse, forever part of the human experience. Whether wandering the halls of Elsinore or ravaging the foundations of the House of Usher, such tales have haunted our cultural collective. The history of the Croke-Patterson Mansion is a collection of such stories.

Built in 1890 from the design of the architect Isaac Hodgson, the hauntingly beautiful mansion warrants a volume on the sheer weight of its historical merits alone. Throughout the decades, the house would assimilate the fortunes and fates of some of Colorado's most influential families. Later, as the Gilded Age slipped into obscurity, it would bear witness to the mundane travails and tragedies of inhabitants from all walks of life. For many, this historical pedigree should prove enough. Yet in the last three decades, as the splendor of the grand estate fell into disrepair, there arose in its place a most sinister subplot. The Croke-Patterson Mansion has been locked and secured, the name only spoken in hushed tones. The windows no longer regard those looking in but hold the secrets of what may be looking out.

There are many stories about this house, and they are all painstakingly collected for you in this ambitious volume. The stories of the Croke-Patterson are terrible, tragic and often terrifying. In this book, we find some of our most compelling motifs of the haunted house in shocking detail: infanticide, wandering spirits, bodies in the walls and suicidal mothers. Like Plutarch, these authors seek to chronicle them all—before we forever bar the doors to stop the howling. The most overarching constant in the survival of our folkloric legacy is that we have storytellers to keep it alive. In short, ghost stories can only survive with our willingness to refuse to let them die. Author and researcher Ann Alexander Leggett is made of such stuff.

I first had the pleasure of meeting Ann during my investigation of the alleged haunting of the Macky Auditorium tower at the University of Colorado in Boulder. I was instantly impressed by her dedication to the investigative process, her methodical approach to research and her extraordinary mastery of the storytelling craft. Her weaving of historical fact with regard to folkloric context and journalistic panache sets her apart from the droves of less accomplished authors in the genre.

The addition of her daughter and writing partner, the brilliant Jordan Alexander Leggett, has resulted in a text that serves to preserve with equal measure both the natural and supernatural history of the Croke-Patterson Mansion.

My own experience with the mansion occurred last fall in my day (and night) alone in the sprawling structure, assisting the Rocky Mountain Paranormal Research Society with an exhaustive investigation of the supernatural activities attributed to the house. As an academic—and of the philosophical bent of my predecessor, the satirical historian Thomas Carlyle (who wisely noted that "no ghost was ever seen by two pairs of eyes")—my skeptical and scientific nature seemed sure to preclude all fancies of the supernatural. Yet as I wandered the uneven hallways and warped floorboards in the great stillness of utter solitude, I, too, for a brief moment, found it easy to momentarily indulge my own romantic illusions and the fantastical conjurings of the imagination. It was a remarkably easy—and remarkably human—psychological lapse, and one hopefully to be shared, occasionally, by the readers of this book.

Is the Croke-Patterson Mansion haunted? While I found no evidence to persuade me, I was, however, overcome by the overwhelming evidence of the life of its supernatural legacy. As night fell and I sat alone in the upper turret window, gazing at the streets below like some plaintive specter, I was amazed to witness just how many passersby were affected by the mere presence of the house. Paces were quickened, whispers were thrown and children raced away to beat the sun's descent. If in this sense alone, the spirits of the Croke-Patterson are alive and well. Indeed, if by haunted we mean the overwhelming cultural influence of those remnants of past experiences so impressed upon the locale—the collective garments of decades of joy, fear, tragedy, awe, regret and sorrow experienced by its many inhabitants—then I assert that the Croke-Patterson is "haunted." The continued fascination, the late-night legend tours and the enduring schoolyard warnings provide evidence enough. With regard to the Croke-Patterson Mansion, the "ghosts" have not yet been put to rest.

For the first time, with this book, we have a thoughtful and comprehensive compilation of not only the historical legacy of the mansion but also of the Croke-Patterson's most infamous supernatural assertions. These stories serve not only to thrill and terrify; their collection and preservation remain a vital and important folkloric legacy of the reflection of our own collective fears. I boldly predict that time will prove this wonderful book the definitive text of these collected tales.

Thus, the pursuit of shadows endures, and whether such examinations yield the long-sought proof of life beyond the mortal coil or whether the darkness is scattered by the shocking illumination of science, the essential thing remains their relentless pursuit.

Jack Hanley
Folklorist and Historian
Boulder, Colorado

ACKNOWLEDGEMENTS

S pecial thanks to:
 Jane Carpenter, for being our intrepid researcher, editor, friend and moral support guru (What NOW?). Jane's voice can be heard throughout this book, and without her we would still be working on it.

Sean Bennett and Cory Phillips, for their generous help with accessing the house. Without their support, this book would not have happened in any way, shape or form.

Mary Rae, for her passion for Denver's historic homes and for saving this old house.

Krista Socash, for her continued help with all things psychic.

Jack Hanley, for the wonderful foreword and his amazing enthusiasm.

Valerie, for being an all-around sport and a supportive friend (and for being brave in the house).

Coi Drummond-Gehrig, for being the queen of historic photos.

John Olson, for digging through files for us and cheerfully answering our never-ending questions.

Bryan Bonner and Kevin Samprón, for being pros and for making it fun.

Peter Boyles, for the inspiration and the introductions.

Becky LeJeune, for being persistent yet calm and for keeping us on track.

Nic Leggett, for being his arty self.

Scott Leggett, for his devotion to tedium.

To those who gave us interviews via e-mail, phone and in person, this book comes alive because of your stories.

To everyone involved in the making of this book—thank you, thank you, from the bottom of our hearts.

Introduction

This book doesn't even begin to give this story or this endeavor the credit either is due. What we thought would be a straightforward research project pulled us in and would not let us go. We found that we were not alone in feeling the impact the house has had on residents and researchers, visitors and voyeurs alike. Once entangled with this house, once it has its provocative and expansive arms around you, you cannot escape. It whispers in your ear like a long-forgotten lover, waking you in the night with endless questions and a perverse desire to return, no matter how many times you've said, "This is the last time." As if indulging a guilty pleasure, we kept making excuses to go back, even if just to linger outside for a moment. Tilting our gaze upward at the tall towers that stood in stark contrast to the bright blue sky, we would muse, "We need more photos of the interior." "My friend hasn't been inside." "Did we describe that room well enough?"

This house has come to life within us, as it has in so many owners, tenants and passersby. The research led us to dead ends, boarded-up passages, labyrinths and layers of red tape. We fought to cut through it all, to provide you, our readers, with the most accurate portrait of the Croke-Patterson Mansion that we possibly could. All the while, the house whispered, tempting us with morsels of rumors, information and tales. Unfortunately, we could not answer every question or explore every aspect in the time or pages allotted us. Quite frankly, we began to feel as if we could go on forever, as one bit of information morphed

into yet another, more absorbing bit and then into another, like a fabric unraveling. This house has alternately fascinated and worried us and led us to marvel in both wonder and fear at its impact on us over these few short months.

We invite you to visit the house yourself, within the pages of this book or otherwise. Engage it and build your own experience within it. But don't be surprised if, some weeks or months later, you find yourself awake in the night with some nameless and burning desire to return.

AND SO IT BEGINS

E verything about this house is layered in shades of gray. There is not a single piece of its history that is clear or unblemished, neither a fact that is undisputed nor a rumor that has any solid root. From its age to its physical address, its owners to its architects, its dates of occupancy to its uses, everything is tangled and inconsistent. Sources of information on this house range from second-, third- and fourth-hand accounts online to one-hundred-year-old letters from an owner to his wife. City records show the building date as off by forty-three years and the structure to be a mere 2,827 square feet—an understatement of approximately 11,000 square feet—so even what should be the most straightforward and reliable sources can display some of the most distorted information. Perhaps the search into the background of any house this old would deliver similarly disparate results, but there is something about this one. It is full of twists and turns and tragedies. It grabs hold and doesn't let go.

Seeing the mansion for the first time is quite an experience. Once an architectural gem of Capitol Hill, the looming red sandstone structure is now surrounded by apartment buildings and seems to perch high on the corner of 11ᵗʰ Avenue and Pennsylvania Street. According to records, the house was built to resemble a French chateau, but in reality it looks like a nominally tamer version of Poe's House of Usher. The exterior of the building has seen better days, and evidence of patchwork repairs on the sandstone is not terribly well concealed. The inside still carries some vestiges of office life, the carpets have been torn up and the front door bears

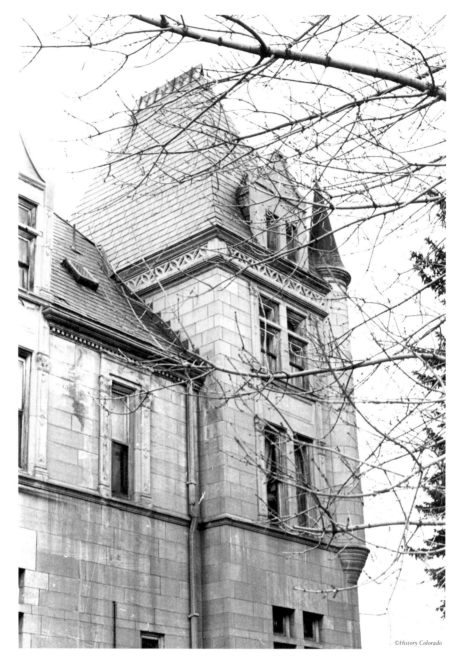

The northwest corner of the Croke-Patterson Mansion as it looked in 1973. *Photo courtesy of History Colorado, #F-29559 #3.*

the somewhat stale moniker "Ikeler Castle." However, its crumbling ledges and archways give way to glorious stained glass. It may sound trite, but it is breathtaking—in a "dark and stormy night" sort of way. The question that immediately comes to mind is: what happened here? And that's before hearing any of the folklore that surrounds this place.

The house has been occupied by single families, but only the Patterson-Campbells seemed to do well there, staying for twenty-three years. The Sudans owned the mansion for twenty-five years, with different members of the family living in it for a large portion of that time, but other residents left after a few months or never felt comfortable in the house. Changing hands a dizzying number of times over the years, and even becoming apartments and offices, the mansion's owners have ranged from state and federal statesmen to doctors to banks that repossessed it in foreclosure. There are some differing accounts on when it was actually built—the best we can ascertain is that it was finished sometime between 1891 and 1892—and the physical address has changed over the years to the point where no one can quite agree on what it actually is today. All of these discrepancies and more have led to some of the most difficult research we have ever done, and that is where our story begins.

With such a perplexing subject at hand, it really shouldn't come as a surprise that a strange series of events would begin to unfold. It all started with a friend who was hosting a Halloween event in the mansion in 2010. Peter Boyles, a longtime Denver radio personality, has hosted several radio broadcasts from this house, as well as from other haunted locales. His show has always been wildly popular, as it typically includes appearances by paranormal groups and local historians, as well as an overview of the history and the hauntings of the show's setting. The timing of his most recent show in October 2010, broadcast live from the Croke-Patterson Mansion, happened to correspond with an offer to us from The History Press to write a book on a subject of our choice. Given the topics of other books we've written, the combination of rich history and reported ghost stories of this old house seemed a perfect fit. It was more than a little strange how the entire project evolved and seemed to take on a life of its own. Peter made introductions for us to the current owners, who were very generous with their time and knowledge, even allowing us access to the old mansion, then empty. During our first visit with them, our minds wandered as we debated whether we wanted to take on a project so crazy. Research the history and the hauntings of one of Denver's landmark properties? Get involved in the paranormal world and work with what has been called the most haunted

place in Denver? We snapped back to reality when one of the owners said: "And the lockbox code is easy to remember, it's 'YES!'" Well, that was a pretty clear sign that we were supposed to write this book.

At that point, we had done some cursory research on the Internet and had begun to see the discrepancies in the home's history and the sheer volume of folklore associated with the mansion. But we had also begun to see the effect the house had on people, some with previous associations to the house and some with none. Once the contract was signed and the research began in earnest, odd little things began to happen. We remembered we had a book detailing the history of Capitol Hill, which we had picked up at a garage sale and had promptly shelved and forgotten. After a surprisingly brief search, which revealed the book to be at the very top of a box in the basement, it fell open in our hands to a chapter on the Croke-Patterson Mansion.

In one of our earliest searches online, we found a woman who used to have an office in the home. In her blog, she alluded to her intense experiences in the house during her time there. We e-mailed back and forth a few times, and she was initially reluctant to talk to us, fearing that her experiences would not be taken seriously. She finally agreed to send us some basic descriptions of what she had felt, saying that at the end of the day she was never afraid for her physical safety. When asked what it was that she had feared, she responded simply, "I feared for my soul." Of course, that only piqued our interest more. We tried to press her for more details, but she fell silent for some time. The last we heard from her was an e-mail that said: "Good luck with the book."

We even had people come up to us as we were leaving, entering or taking pictures of the mansion, all of whom had a story. One man, who said he lived in the neighborhood, flagged us down one day and asked if we'd seen any ghosts inside lately. He told us he'd been frequently amused to see people start to walk down the street toward the house and then, after looking up at the daunting façade, turn and cross the street to keep from walking in front of it. Another young man who lived a few blocks up the street reported seeing the face of baby in a second-floor window, and he wondered if the place had been rented. It had not, in years.

We began to discuss the project with two paranormal groups that had previously encountered the house in one way or another. They were both more than excited for another chance to interact with the place. We also did room-by-room walk-throughs with psychics—one who had never been involved with the house before and two others who had. Despite their initial

reluctance to revisit the house and recall their frightening visits from years ago, these two decided to return to aid us in our research.

All of the people coming out of the woodwork with firsthand experiences and stories about the mansion were encouraging after our online research had yielded such insane and unbelievable rumors and coincidences. Tales of murderous undertakers, suicidal mothers and babies buried in the basement vie for Internet fame with fluke happenstance: the implausible number of women in the house's history whose names began with "M," the bizarre inability of anyone to get Thomas Croke's middle initial right and the baffling lack of information on the transfer of ownership. It was an irresistible puzzle.

It's interesting to look back at our journey, now that it's over. What are the odds that the publisher would ask us to write a book in the first place? How crazy was it that we had just met Peter Boyles socially and that he was about to do a radio show in the mansion and was willing and able to get us access to the building? Was it a coincidence that one of the mansion's owners and his second wife had lived right next door to one of our business clients until just recently? (Side note: it was this owner's first wife who committed suicide in the house and was the subject of many of the rumors.) But perhaps the most bizarre twist came at the very end of the project. On a Sunday morning in July, we sent what we thought was the final manuscript to the publisher and set off to Santa Fe to celebrate a birthday and the completion of the book. At lunch some seven hours later, we received a Facebook notification from a woman whose family has been very close to ours through three generations. Her Facebook comment revealed a startling connection: our lifelong friend is the great-granddaughter of Thomas B. Croke.

All research aside, we had some bizarre experiences of our own in the house. During one visit to the house, a friend found a newspaper page in the ashes of the coal furnace in the basement. The page was from the 1970s and seemed pretty innocuous to us—until we noticed that it contained a small reference to a Colorado state senator, Thomas Iles. Coincidentally, Iles had held office immediately before the first owner of the mansion, Thomas B. Croke, became a state senator. We placed the page in a pile of trash on the main level and never gave it another thought. Three weeks later, as the same friend was walking through a small pantry area, she felt compelled to open an oddly shaped cabinet door. The cabinet was empty and clean, save for that newspaper page, which had mysteriously reappeared.

Everything lined up for this book to work, but that's not to say that researching it or writing it was easy. The amount of folklore that came with

the house was difficult to overcome. Almost everyone had an opinion of what was going on, who was haunting the house or what had happened there. Everyone who knew of the house had heard a story. We quickly found that the urban legends about the house were everywhere: in magazines, on TV shows on the Internet. It was interesting to hear how one story spun into another, which turned into yet another and so on. As we learned more about the mansion, we felt compelled to get the history straightened out as much as possible and to find the root of the ghost stories so that this house could have the respect it deserved as a venerable piece of Denver's history.

But where to start? The history alone is intriguing, and if that weren't enough, the mansion has been called the most haunted house in the United States. We wanted to provide the context of an extensive history on the mansion, as well as information on the purported hauntings, because we truly believe that from the history come the ghosts. Ghost stories, as we have learned, can be invented and oftentimes seem redundant and even boring. Almost everyone is familiar with the stories commonly heard around the campfire: a murder victim exacts his revenge, a scorned mistress haunts her lover's bedroom, a neglected orphan seeks attention. These worn tales take place in old boardinghouses that once housed the criminally insane or in mansions that once were homes for unwanted children, but invariably these places are unnamed and simply unrealistic. Fictions like these are spawned from a basic human need to feel fear, to feel the chill of goose bumps and the hair standing up on the back of our necks, to be thrilled by the adrenaline that courses through our veins when the teller screams, "Boo!" But these campfire yarns tend to leave us unsatisfied, yearning for more. We want something real, something substantial to sate our thirst for the truly frightening. When the ghost stories are tied to a location we might walk by every day—a place we can actually visit—and when the ghosts are tied to the history of that place, now *that* is truly terrifying.

However, the challenge of writing a complete history of the Croke-Patterson Mansion was enormous. Maps showed conflicting information, the address had changed repeatedly and city records showed tremendous discrepancies all across the board, adding even more confusion to the mix. Some records were so old that they were stored in the basement of Denver's City and County building, bound in crumbling cardboard and corduroy. We were on a perpetual search for death certificates, building plans and elusive obituaries as we hunted through dusty archives and record books. We were sent to the wrong offices at every turn and were constantly told that "those records no longer exist." We spent countless hours pacing up and down rows

of headstones in cemeteries and even carefully waded through twelve boxes of Senator Thomas Patterson's personal correspondence and photographs.

We learned how paranormal researchers conduct their investigations. We were alternately terrified and mystified by the findings of psychics and the dramatic reactions of our friends and relatives toward the house when they visited. Equally unnerving was how the house seemed to disrupt our activities even after we left it. At every turn, something went sideways or seemed odd. Notes we had taken and documents that we acquired disappeared from our files regularly, and we would quarrel over who had misplaced what, only to mysteriously find the missing item back in the folder where we had left it or never find it at all. A copy of a death certificate pivotal to our research first appeared by chance and then vanished just as abruptly. The paper reappeared in Ann's files, was misplaced again and then turned up in Jordan's files (thirteen hundred miles away)—five times.

The mansion drew us in and kept us enthralled. There were times when we could not imagine entering the house again for any reason, even to take another photograph. And then, for some strange reason, we'd begin to think of excuses to return. We would look forward to seeing the place again, to revisiting the rooms that gave rise to the ghost stories. Those visits were not always pleasant, however; the strangeness never ended. Word got out that we were writing a book about the house, and people wanted to read our manuscript before it even went to the publisher. Everyone wanted to know what we had learned about the infamous Croke-Patterson Mansion. After a while, we became protective—not of our book, but of the mansion itself. As strange as it may sound, despite being affected mentally and physically—and being spooked on a daily basis—we wanted the house to be at peace. We hoped that it would become viable again. It upset us that so many people just wanted to make a buck off it, retelling lies and tall tales. The mansion became *ours* in a sense. And that thought was, well, frightening.

We visited the house with psychics and investigators and also with friends and family who were understandably curious about our endeavor. The majority of these folks were what we'd call "moderate to extreme" skeptics. One such friend, Jane, is still searching for an explanation for what happened to her on her last visit. Jane assisted us with historical research and had been in the house once before her unsettling incident. Describing herself as open-minded but "about as sensitive as Sheetrock," Jane was taking photos on our last trip to the mansion and spent a great deal of time in the basement. Upon leaving the house, Jane headed to her car, and as she opened her door, she looked up at the mansion and thanked it

(a habit of ours after visiting)—then promptly threw up. With no warning whatsoever, she was violently ill and then, an instant later, totally fine. This happened to another visitor as well. As our research for the book wound down, we didn't have a reason to visit as often, and we were both thankful and melancholy about that. Ultimately, our time at the mansion affected us even after leaving and led us to seek psychic cleansings to make the agitation and uneasiness subside.

The process of writing about the Croke-Patterson Mansion was certainly an adventure. Before we spent all those hours in archives researching the history of the house, we convinced the psychics to walk through the structure with us. As we wandered the gloomy halls and explored the dark corners of the basement rooms, or simply stood quietly in the mansion, we felt the real excitement begin. After working with the psychics and hearing their thoughts, we came to realize one undeniable truth: just as the stories don't end with the house, they didn't begin there either. We quickly realized that it all begins with the land.

WHAT LIES BENEATH

The Croke-Patterson Mansion takes up lots one through three on Block 77 of H.M. Porter's Addition in Denver's Capitol Hill neighborhood. It is now a good fifteen feet above the sidewalk, sitting on the corner of 11th and Pennsylvania, and though it seems that it used to be closer to street level, it has always been a daunting presence in the neighborhood. Every source on this house seems to have a different reason for its purported hauntings: its proximity to Cheesman Park, supposedly one of the most haunted places in the United States; its potential for being a forgotten Native American burial ground; or even the fact that the City Ditch ran through it, as water is a conduit for energies not of this world. However, every theory boils down to one accepted truth: the issue is not with the house but with the land itself. Psychics, paranormal investigators and others familiar with the house have all made the same claim: knock the house down and rebuild it, and the hauntings will remain. The history of this particular plot of land is, at best, unclear, but from settlement to city, there are extensive accounts of Denver and Capitol Hill. To better understand the land and its potential for paranormal activity, it is with these accounts that we begin.

Denver, Colorado—a city of 600,000 people (though there are almost 3 million in the Denver metropolitan area) covering 154.9 square miles—has existed through good times and bad, known by one name or another, since 1858. It is currently renowned for its extensive involvement in national trade and industry; its central location makes it ideal for the exchange and transportation of goods and services from coast to coast. It also has a large

stake in tourism, being a gateway to many of Colorado's ski resorts, and it is a prime location for many federal agencies, including the Denver Mint and the Denver Federal Center. However, Denver's roots come from a different, less auspicious beginning: the land.

In 2011, an aerial photograph of Denver reveals shiny skyscrapers, miles of highways, an extensive patchwork of residences and brown earth. Approximately 160 years ago, however, it would have been a very different story. In the 1850s, what would become the state of Colorado was a vague, mostly undefined section of the West. Home to the Cheyenne and Arapahoe tribes, the Denver region would not see many white settlers until the Pikes Peak Gold Rush of 1859. The rush found its origins in a number of California-bound gold-seekers who panned an unremarkable bit of gold from various streams at the foot of the Rockies in 1849. The California gold rush was in its heyday, and the quantity found in Colorado wasn't enough to write home about in comparison, so it was regarded as a fluke and swiftly forgotten.

However, as many weary and impoverished miners returned from California worse off than they had begun, the rumors of gold crept back into circulation. A small party headed by William "Green" Russell made its way toward the South Platte River Valley in early 1858. After camping near what is today's Confluence Park in downtown Denver, and prospecting Cherry Creek and Ralston Creek without much success, they turned to Little Dry Creek. In this tiny creek in what is today the suburb of Englewood, they found over six hundred grams of gold, the first significant gold yield in the Rocky Mountains. As soon as word got out, the Pikes Peak Gold Rush was on, bringing a flood of prospectors and investors westward to find new settlements along the banks of the South Platte and its tributaries.

Variously named Auraria, Arapahoe City, Golden City and even St. Charles, the city's pioneers finally agreed on Denver City. William Larimer, one of the first to lay claim to land in the area, named it after the governor of Kansas Territory, James W. Denver, in an attempt to curry favor toward future statehood. Denver City was a booming settlement for some time, particularly when Colorado Territory was officially created in 1861, but several variables led to it being nearly abandoned by the mid-1860s. A primary reason was the Union Pacific Railroad's decision to utilize Cheyenne rather than Denver as a point on its transcontinental railroad. Many settlers fled Denver for Cheyenne between 1866 and 1868, and the population fell from five thousand to three thousand, leaving many landowners financially strapped.

One such landowner, Henry C. Brown, had homesteaded the land that would become Capitol Hill. In fact, Richard Whitsitt had previously laid claim to that particular land in 1858 alongside William Larimer, but Whitsitt never built a home or dug a well, as required under the Homestead Act, nor did he properly file the paperwork with the land office. Brown appeared on the scene as a carpenter in 1860 but abandoned his shop in 1863 to follow the allure of real estate. He took advantage of the Homestead Act to lay claim to 160 acres, the maximum allowed, between present-day 11th and 20th Avenues, from Broadway to the alley between Grant and Logan. Brown purchased the land for a discounted homesteading price—$1.25 an acre instead of $2.50 an acre—and stood his ground with his carpenter's hatchet in hand, though Whitsitt threatened him. He held the land and planned his streets to run north–south/east–west, opposing the city's primarily diagonal plan that followed the Platte River, assuming correctly that Denver would grow in his direction and that his dry, sandy bluff would, in time, be prime real estate. Dubbed "Brown's Bluff" (a name that fit both literally and figuratively), the land lay mostly vacant for some years until Brown and almost a dozen others started donating land to build Colorado's Capitol Building.

The capital was much disputed, as the surrounding towns weren't terribly fond of the pompous attitude afforded by Denver's status as a primary trading center in Colorado Territory. The seat of government was relocated quite a bit, even settling in Golden for almost a decade. In 1867, Territorial Governor Alexander Cameron Hunt donated ten acres of his holdings in West Denver to the territory, assuming it would seize upon the free land and nest the capital permanently in Denver. Once Denver was designated the territory's capital, H.C. Brown and ten others also donated ten acres apiece, each wanting the Capitol Building sited in his own neighborhood to boost land values and add to his growing fortune. The Territory of Colorado was grateful but lacked the funds to build a Capitol for some years. The legislature continued to move around, meeting in rented halls in various towns even after Colorado achieved statehood in 1876. All the while, Brown's land was in jeopardy. Too far from Denver proper to be considered prime real estate, he had to sell off bits and pieces of his land to survive. However, Brown was convinced that his luck would change soon, and in the late 1870s, it did.

The state's first lieutenant governor, Horace Tabor, a businessman of considerable status, commissioned a twenty-room mansion on the hill above Broadway and breathed a spark of life into what soon became known as "Governor's Row." As it was generally thought that one's physical

elevation mirrored one's standing in the community, the status-seeking citizens of Denver emulated Mr. Tabor by building their own mansions on Capitol Hill. Thus, Brown's Bluff became what Henry had dreamed of all those years: a hilltop neighborhood populated with the wealthy and affluent citizens of one of the richest emerging trading cities in the nation. The future builder of the Croke-Patterson Mansion, Thomas Bernard Croke, also had a change of luck around this time. He stepped off the train in Denver in 1874, ready to begin a new life as a schoolteacher. Little did he know at the time that he, too, was destined to become one of the city's affluent residents of Capitol Hill.

Meanwhile, the ten acres Brown donated toward the site of the Capitol were going nowhere, so he reclaimed the land in 1879, as it had increased in value to about $30,000 by that time. The state, infuriated by his brazenness and suddenly certain that the Capitol should be sited in exactly such an elevated and affluent neighborhood, sued him for the land and, after six years in court, won it back. Though the edifice wasn't finished until 1908, it lent its name to the neighborhood thereafter known as "Capitol Hill."

The young city of Denver sought to be known not just for its wealth. It strove to become recognized as one of the more beautiful cities in the nation as well. Because Capitol Hill was at a higher elevation, it afforded a beautiful view of the Rockies unmarred by the terrible pollution that Denver had to contend with in the late nineteenth century and benefited from clean air brought by the prevailing southeasterly winds. However, the hill was very dry and sandy, characteristics that, according to explorers like Zebulon Pike and Stephen Long, did not lend themselves to "white civilization." So a city ditch was planned to supply the neighborhood, delivering unpolluted water for drinking, firefighting and irrigation. This evolved into a landscaping movement encompassing more than one thousand miles of ditches, boosting Denver's image as a garden city and causing residents to dub it "Little Venice."

Other events took place, mainly in the 1860s and 1870s, that had a direct effect on elevating Capitol Hill's desirability. In April 1863, a huge fire destroyed seventy buildings—almost two-thirds of the city—and over $250,000 worth of stores and property in only a few hours. The Great Fire, as it was called, brought about new legislation regarding construction that required a heightened level of fireproofing in each new building, making brick and stone a staple of downtown Denver. This particular outlook made Denver a more stable and attractive place to live in the late nineteenth

century and is much of the reason why so many of the buildings have survived through to the present day.

Another lasting influence on the population of Denver was the flood of May 1864. Because West Denver was lower than the eastern parts of the city, it suffered the most damage. All construction on the banks of Cherry Creek came to a halt. A good number of residents and business owners gave up on West Denver altogether and moved to the east side, increasing the populace and the prosperity of eastern neighborhoods, including Capitol Hill. A similar push to urban centers throughout the Great Plains was set in motion by swarms of locusts in the 1870s, the very worst year being 1875. Nearly biblical in size, the almost 200,000-square-mile swarm ate everything in sight in parts of Colorado, Kansas, Nebraska, Missouri and even Iowa. A full year's worth of crops were lost on many farms, and an unprecedented number of farmers simply gave up and moved to Denver and other cities to try their luck in a more urban, commerce-driven environment.

According to records at the Denver Water Board, construction on what was to become the City Ditch began in 1860. Due to poor engineering, the project failed in 1861 but was revived by John W. Smith in 1862, with the help of Richard S. Little. When it was finally completed in 1867, the ditch was almost twenty-four miles in length and irrigated thousands of acres, allowing agriculture to secure a solid foothold in Colorado. At the time, the conduit was known as Smith's Ditch and ran through Smith's Addition, John W. Smith's claim that was immediately adjacent to what remained of H.C. Brown's Addition. It also cut through a portion of Porter's Addition, owned by Smith's son-in-law, Henry M. Porter. More specifically, the ditch ran through a corner of Block 77, Lots 1 through 3, approximately between what is now the Croke-Patterson Mansion and its accompanying carriage house.

Smith sold the ditch to the city in 1882, and it was renamed City Ditch in recognition of the vital role it played in allowing the city of Denver to flourish and grow. Each surviving map of the ditch seems to be drawn a little differently, but the water definitely carves its path through that particular block in Porter's Addition, hence the theory of water's influence as a conduit of the paranormal on the Croke-Patterson Mansion and its occupants.

J.W. Smith was very active in Denver real estate around this time and was one of several prominent Denver pioneers who donated land parcels to the territory for the building of the Capitol. As Capitol Hill grew, he took on the responsibility of naming some of the streets that ran through his addition. He named Pearl Street after his granddaughter and Pennsylvania Street after his birthplace.

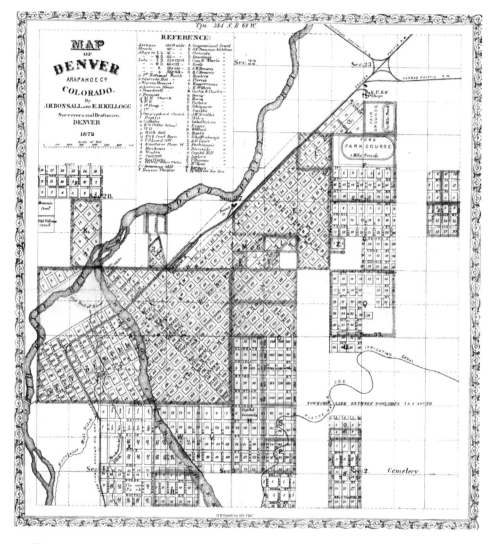

This 1872 map shows Block 77 of H.M. Porter's Addition (in Sec. 3, near the bottom center of the map), upon which the Croke-Patterson Mansion was built, and Smith's Ditch (City Ditch) is shown running through the property. *Photo courtesy of Denver Public Library, Western History Collection, J.H. Bonsall, #CG4314.D4 1872.B6.*

Over the years, the City Ditch has been rerouted, straightened and buried. Given that the original waterway was open to all, city authorities became concerned that pigs and other domestic animals were fouling the city's precious water supply, which might lead to cholera and other disease. Eventually, whole sections of the ditch were covered over, allowing the pure waters of the South Platte to flow beneath the streets and homes of Capitol

Hill. Much of this occurred in the years before Croke purchased his lots and began construction on his mansion, so it can't be said for certain that the ditch was visible for any part of the house's history. However, it was most definitely present, bringing about an interesting coincidence: Thomas Croke, who would later become known as one of the "fathers of irrigation," built his house on top of Denver's earliest irrigation system.

There is very little information on just exactly how Lots 1, 2 and 3 of Block 77 changed hands from the original homesteader, H.M. Porter, and came to be owned by Thomas B. Croke, but the most likely agent was an energetic real estate entrepreneur named H.B. Chamberlin.

Humphrey Barker Chamberlin was born in Manchester, England, in 1847. He came to America with his parents in 1854 and grew up primarily in New York. His failing health led him to Denver, Colorado, where his bother-in-law was settled. They went into partnership together and soon became a real estate force to be reckoned with. Chamberlin had an "unwavering confidence in Denver's progress" that allowed him to see three or four steps ahead in the real estate business. In 1882, he bought out the Porter, Smith and Brown Additions and also acted as an agent for much of Emery's Addition to the south, which included the south half of Block 77. Chamberlin was able to put much of Capitol Hill on the market, taking full advantage of Denver's booming growth. This purchase in 1882 is as close as we could get to the final step before Croke bought the land and built the mansion.

Precisely from whom he bought the land notwithstanding, it is apparent that Croke purchased the lots in 1890. He engaged prominent architect Isaac Hodgson Jr. and builder J.M. Cochran, and together they broke ground on what remains to this day one of Capitol Hill's most beautiful and historic creations.

Before embarking on the life and times of Thomas Bernard Croke, it is important to note a few other points on the land. The history of the platting and sale of the land, as well as the City Ditch, has been catalogued more or less, but these specifics do not in themselves define why the land is thought to be a conduit for the paranormal. Though not as easy to source or prove as the simple sale and purchase of a few lots on a hill, the speculations range far and wide. Accepted to varying degrees are theories outlining the possibility that the land is sacred Native American ground, that ancient ley lines run through or intersect beneath the mansion or that the water itself flows with paranormal energies.

Though much of the Front Range of Colorado was home to Native Americans, namely the Arapahoe and Cheyenne tribes, it is very difficult to

pinpoint exactly which of their lands they may have held sacred. Another facet to the problem is that before 1850, Native Americans had very few land disputes in Colorado; being a nomadic people, the tribes moved and camped as they saw fit. Before the Pikes Peak Gold Rush began in 1859, the United States government created a treaty that deeded most of present-day Colorado to both tribes, though it also allowed U.S. citizens to pass through or reside in the territory. As the gold rush hit, homesteaders and miners alike disregarded the promises previously made by the government, and relations with the Native Americans were further strained. In 1861, a few tribal leaders from both the Cheyenne and Arapahoe tribes agreed to cede most of the lands originally guaranteed them, reducing their holdings to a small sliver of the original reserve between the Arkansas River and Sand Creek. The continual reduction of land that was left to the tribes most likely led to numerous relocations of sacred ground, including burial grounds. While a Native American burial ground may indeed exist beneath the foundations of the Croke-Patterson Mansion, the same could easily be assumed of other, far less haunted properties in Colorado as well.

Ley lines, another theory behind the hauntings and energies present at the mansion, are something of a tricky subject. Originally posited as navigational lines in 1921 by a British gentleman by the name of Alfred Watkins, ley lines were named after an Anglo-Saxon word meaning "cleared ground." Watkins, an amateur naturalist, had noticed an extensive grid of eerily straight lines in England that connected some ancient sites to one another, including Stonehenge, burial mounds and other monuments from times past. Not only were these lines preternaturally straight for miles, but they also abruptly turned at sharp angles in a way that ordinary human and animal trails do not.

Another theory on the cause of the hauntings regards the water. Smith's Ditch, later to be elevated in status to City Ditch, did flow through Block 77 of Porter's Addition, as shown on the 1872 map of the neighborhood, and much of the twenty-four-mile long ditch still carries Denver's water to this day. The ditch may or may not have been completely covered as it flowed northeastward through Croke's property, but it's difficult to dismiss the notion that water in such proximity may have had a powerful effect on the house and its residents.

Due to its conductive nature, water has long been thought to be a transporter of things that go bump in the night. Paranormal activity cannot be classified scientifically, and it definitely cannot be labeled as electrical in nature, but one theory is that because paranormal entities

are energies—mainly electric—these entities can manipulate electrical technologies and are conducted by the same means. This gives credence to instances of light switches turning on and off, televisions turning on when they are unplugged, white noise and more. Another theory holds that water bends light and slows it down. Therefore, if paranormal energy is anything at all like light, it may be most easily seen or recognized when it is impeded or trapped by a body of water. Finally, water has been considered a portal between the realms of the living and the dead in mythologies as old as storytelling itself.

The theme of water as a portal of the spirit world is common throughout human storytelling, including contemporary arts, so it is no surprise that it has been explored as the reason behind the energies in the Croke-Patterson Mansion. Given the fortuitous discovery of gold near the confluence of the South Platte River and Cherry Creek, barely two miles from where Thomas Croke was to build his house, and the supreme importance of the City Ditch to the growing population, the many influences of water on the mansion are undeniable.

In the end, almost as many questions are raised as answered. Is it possible that ley lines, and the energies they hold, converge in this immediate area? Is it possible that a "bad" intersection exists in the earth beneath the Croke-Patterson Mansion? Going into this research, we were very skeptical. However, nearly every psychic or sensitive individual we brought into the house has asserted that some sort of "intersection" lies beneath the house and that it is this convergence that draws all of the paranormal energies to the house itself.

THE RENAISSANCE MAN

From our twenty-first-century perspective, we may wonder why anyone would attempt to build a home on such compromised and potentially treacherous land. However, nothing of the paranormal clouded the vision of the entrepreneurs riding the wave of prosperity back in the heady days of the newly minted city of Denver. The most successful of Denver's businessmen looked only toward the future, and the sky was the limit as they competed to build their legacies.

Thomas Bernard Croke secured a lasting impression on Denver when he built his fourteen-thousand-square-foot house on Capitol Hill in 1890. Though he may not have foreseen it, his house would survive him by over seven decades and would be quite the presence in the neighborhood from the day it was finished. The Thomas Croke who built the house was quite different from the man who first came to Denver in 1874 and definitely not the same man who would later scheme to build the largest dam in the world in the early twentieth century. His mansion is but a fraction of the heritage he left to Denver, as the story of his life reveals.

Life began for Thomas Croke in Magnolia, Wisconsin. Exactly what year it began is left to our discretion, as census records and biographies alike cannot agree in that regard. He may have been born as late as 1856, but most scholars seem to agree on his headstone's inscribed date of 1852, as when he moved to Denver in 1874, he had already spent some time as a schoolteacher in Wisconsin. He studied for and received his certification to teach in Colorado but chose instead to clerk at the prosperous mercantile

Thomas Bernard Croke, circa 1901. *Photo from* Representative Men of Colorado.

of Daniels and Fisher. He demonstrated a shrewd business sense from the beginning and climbed the company ladder fairly quickly; at one point, he actually owned a third of the company. He broke from Daniels and Fisher after only a few short years, and using the proceeds of his share in the company, he boldly opened his own shop—Thomas B. Croke and Co.—on Lawrence Street.

During this period of financial success, very little is known about Croke's personal life. Historians mention at least two brothers and that he had a wife, Margaret Dunphy Croke, but very little information can be found on her life either. It would seem that they had two children, but Margaret purportedly died in 1887. When he pulled the permit to build his house in 1890, Croke may have had his parents in tow. We know from a few brief references in various accounts that Michael and Mary Croak were Irish immigrants who had changed the spelling of their last name to Croke upon their arrival in America. Of their lives or ancestry, there is next to nothing in available records.

The great house was most likely completed in 1891, and Croke, his parents and his two children moved in. The magnificent seven-bedroom house was carpeted and furnished luxuriously by Croke himself, maybe even with the help of his new business partner, Carl Thome. Croke and Thome officially partnered up in 1892 to open a store on Welton Street that specialized in carpet and other housewares. Despite his reputation as the "carpet man," Croke was in fact more of a self-styled Renaissance man, a man of many interests and talents. Around the same time he was managing the Croke & Thome store, Croke was also dipping his toes into the broad pond of Denver real estate. He and one of his brothers owned thirty-five hundred acres of farmland near what is now Broomfield, and he also had acquired a small landholding and ranch house in north Denver.

When the silver market crashed in 1893, affecting the entire nation and indeed the world, the young city of Denver was hit especially hard. Of the many effects the failed economy may have had on Thomas Croke,

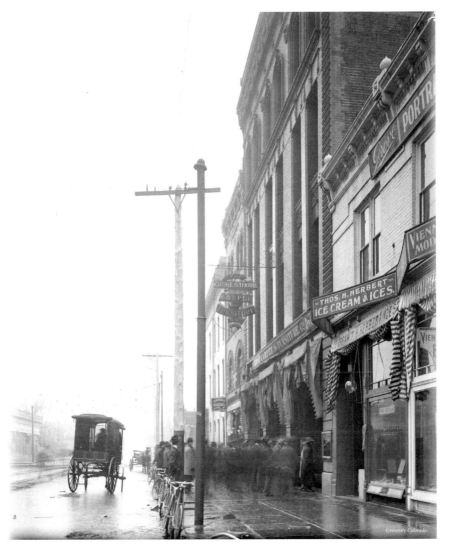

Thomas Croke's business on Welton Street in downtown Denver. Known as the "carpet man" during these years, Croke was in business with Carl Thome. *Photo courtesy of History Colorado, CHS-B1137.*

the greatest may have extended to his home. In all likelihood, the crash meant that Croke could no longer meet his mortgage obligations, and he needed to get rid of his brand-new house. Thomas Patterson, a well-established Denver attorney and politician, stepped in and offered to trade 1,440 acres of land adjacent to Croke's Jones Lake ranch for the

spectacular mansion on Capitol Hill. Another probable factor in Croke's decision to trade was his mother's death in 1892. Successfully negotiating the exchange, Croke packed up his father and his two children and moved out to his ranch house. According to Patterson's letter to his wife in early 1893, Croke left the house fully carpeted and furnished, after having lived there for only six months.

Though Croke had lost loved ones and much of his fortune, he did not give up. He continued to maintain his business with Carl Thome, and he shared substantial landownership with his brother. He managed to keep several properties in Denver, though all were less prestigious than his mansion. Nevertheless, the last forty years of his life certainly were not dull.

The 1905 publication *History of the State of Colorado* describes Croke's professional life, but perhaps even more tellingly, it provides a substantial view of what Croke's assets were by the early 1900s:

As early as 1875, he began buying railroad lands of the Kansas Pacific Company on the six-year installment plan, paying the amounts annually accruing from his savings. This practice continued until 1886, during which period he had acquired 3,250 acres, all within six miles of Denver, north. He has 3,200 acres in one body, enclosed by twenty-seven miles of fence. It is watered by about fifty miles of lateral ditches, reinforced by twelve reservoirs. In 1891 he had 1,200 acres in crops of various kinds. Upon this extensive estate he planted 6,000 fruit trees and 30,000 shade and ornamental trees, suited to the climate and soil. On a part of the ranch or farm, he had many fine horses and cattle. In addition to these possessions, he owned much valuable real estate in Denver.

From this and other accounts of his career, it's clear that Thomas Croke's renewed success was due in no small part to the drive and dedication he brought to each and every project he came upon. Sadly, in 1901, a fire claimed most of his carpet store. Though the flames did not spread to neighboring businesses, his inventory was destroyed and the store gutted. Croke sold Thome his half of the store and plunged wholeheartedly into his ranch land. A few years earlier, he had remarried to one Euretta Burdick, a young woman originally from Wisconsin, and together they made his ranch a home and raised seven children. As his daily life turned more and more to his land and agriculture, Croke became increasingly

interested in irrigation technology, an understandable pursuit given the size of his property.

Eventually, Croke joined forces with a neighbor, Joseph Standley, and together they founded the Denver Reservoir and Irrigation Company. Their partnership turned out to be quite profitable, to the point where word of their ambitious collaborations reached the *New York Times* in 1907:

> *DENVER, June 7—Plans have recently been perfected for the development of what is known as the Stanley [sic] Lake Irrigation System, a plan for irrigating the arid lands about the City of Denver, which will cost between $3,000,000 and $6,000,000 to carry out, and which is said to be the largest private irrigating enterprise ever attempted.*

The dam had been in the planning stages since 1902, and construction did indeed begin in 1907. The original specifications called for the reservoir to cover 100,000 acre-feet. For political reasons, this was quickly reduced to 50,000 acre-feet, with the intention of starting small and reaching the original goal at a later date. That goal was never met; there were structural issues with the dam from its birth, and it was repaired numerous times, limiting its capacity to only 42,000 acre-feet to this day. Standley Lake is currently managed by the City of Westminster, and it is fed by both Clear Creek and Woman Creek.

The dam's original purpose was to irrigate the arid, desert-like soil in and around the Denver metropolitan area, and since its construction it has met that purpose well. The Denver Reservoir and Irrigation Company, later the Farmer's Reservoir and Irrigation Company (FRICO), did much more than scheme to build the world's largest dam; the company also went on to create reservoirs and innovative irrigation systems all over the region. During this time, Croke was able to rebuild his fortune quite well. Unfortunately, his partners at FRICO owed their Kansas City contractor $90,000, so by 1908, Croke found himself in financial trouble yet again.

Despite the roller coaster of financial windfalls and troubles that seemed to be the staples of his life, Croke left his mark on the Denver landscape, both literally and figuratively. He was elected as a Colorado state senator in 1911 and continued to promote Colorado's agriculture and irrigation industries. Neighborhoods, lakes and even a few roads in the metropolitan area still bear his name. Every day, hundreds of

Denverites enjoy the amenities of both Croke Lake, in the suburb of Thornton, and Croke Reservoir, an award-winning renovation project in Northglenn. However, his most famous bequest is the 120-year-old mansion that still stands as a monument on Denver's Capitol Hill. Croke is buried at Mt. Olivet Cemetery in Jefferson County, Colorado, along with most of his family.

THE HOUSE ON THE HILL

I t is fairly evident that Thomas B. Croke set out to build the finest home in Denver, in what was fast becoming the most prestigious neighborhood of all. Beginning with three lots on a block overlooking the young city, and with an unobstructed view of the construction of the new state capitol building, Croke's vision of grandeur began to take shape very early in the spring of 1891.

Designed by Isaac Hodgson Jr., the sheer size of the structure was daunting, to say the least. With approximately fourteen thousand square feet and an attached carriage house that would itself be suitable in size for any family, it was—and still is—a mansion in every sense of the word. Although it's commonly asserted that the house was built in the style of a sixteenth-century French chateau from the Loire Valley, the overall design more faithfully reflects elements of popular American architecture of the period.

The exterior of the mansion is built of spectacular Manitou sandstone. To builders at the time, the label "Manitou sandstone" was sometimes carelessly or disingenuously used, almost as a generic term, but in fact the genuine material was prized for its fine grain and consistent red-orange color. The stone very likely came from the Kenmuir Quarries in Red Rock, Colorado, a small town near the stone's namesake of Manitou Springs. Manitou sandstone was known for its relative softness, making it easy to saw into smooth facing blocks or carve into rich architectural details. The impressive results were expensive and prestigious, and so the stone was used for more than a few grand mansions in the area. Despite its beautiful appearance,

however, the stone's desirable softness would become a liability one hundred years later, as the carved details and smooth blocks continued to succumb to the ravages of weather and modern pollution.

Edgar J. Hodgson, Isaac's brother and an architect himself, pulled building permit #2254 for the construction of the house on December 22, 1890. The builder's name, J.M. Cochran, also appears on the permit. The archival record of the permit, now housed in the Denver Public Library, shows that the city received $18,000. Whether that amount is the estimated cost of the house, which is modestly described on the document as a "two-story brick and stone dwelling," or the cost of the permit itself remains up for debate.

The subsequent owner of the mansion, Thomas Patterson, in a letter to his wife dated 1893, details his acquisition of the property. He traded some land for the house but estimated it to be worth $40,000, making it similar in cost to the nearby Sheedy Mansion (also known as the Grant Mansion) at 1115 Grant Street. The Sheedy home was built within a year of Croke's and was also graced with the prestigious Manitou sandstone. Hodgson's and Cochran's names also appear on a later permit, dated 1892, for Croke's carriage house. The cost, again probably for the construction, is listed at $4,950. The description on the permit says simply, "Barn, 30 x 45."

Considering the French Chateau label, the description of the mansion's design is also debatable. Loire Valley Chateau style was known for its symmetry, with strong horizontal divisions between stories, regular spacing of windows and Mansard rooflines. Rounded arches within this style were relatively uncommon, as was the asymmetrical placement of towers and turrets. On closer examination, the Croke-Patterson Mansion seems to have been patterned more after the Richardsonian Romanesque style wildly popular in North America in the late 1800s, with a just a few added elements of the more ornate Chateauesque style.

Named after Henry Hobson Richardson, the eclectic neoclassical revivalist style is characterized by asymmetrical placement of towers and turrets, tall chimneys and steeply hipped roofs. Rusticated stone blocks form the lower levels, with rounded Roman arches framing entryways set deep into the façade. In contrast to the more formal symmetry of the French Chateau style, picturesque Richardsonian elements seem to be more prevalent in the design of Croke's mansion. While historians may continue to quibble over the architectural influences evident in the Croke-Patterson Mansion, almost everyone agrees on one thing: the house simply looks haunted. A friend of ours noted, "If I was a ghost, I'd live in that house." It's right off of a Hollywood set.

Indeed, the Croke-Patterson Mansion seems to exhibit all the features of the stereotypical "haunted house." Darkened windows tend to intimidate the neighborhood to this day, and the mysterious three-story tower continues to incite rumor and speculation. Though various architectural details have been altered or removed over the years, the substance of the foreboding structure remains.

The high-hipped roof is protected with slate tiles and once had copper ridge cap panels embellished with large fleur-de-lis motifs, further accented by tall spires. Somewhat incongruously, Gothic-style "crockets"—hook-shaped decorations—crept up the various rooflines, while elaborate moldings surrounded the mansion's many third-floor dormer windows. Trios of carved stone finials once topped the dormers, evidence of the French Chateau influence. Oddly, these finials, removed from the dormers sometime after 1948 and each the size of a barstool, are now piled haphazardly in a basement room of the mansion, giving our photographer quite a start in the dim light.

Sadly, many of Isaac and Edgar Hodgson's more eclectic architectural features have been lost to subsequent remodeling. Along with the dormer embellishments, the copper ridge cap and the uppermost roof spires, gone now are at least two of the towering chimneys. The main chimney, a magnificent architectural feature at the front of the house, is prominent in early pictures of the mansion. Sometime between 1908, when photographs show the chimney still in place, and 1948, when an image shows the structure absent, the chimney either fell down or was taken down as a precaution. The mansion had numerous fireplaces on every level, most of which had probably not been used in years, so it is not surprising that the tall chimneys would be dismantled. What is surprising is that the rest of the mansion was spared. According to John Olson, director of preservation programs at Historic Denver, the fact that the mansion survived the removal or collapse of the chimney is noteworthy. "In past years, when a large chimney was deemed unstable, sometimes the entire house would be torn down in lieu of trying to repair the chimney at a high cost. And since the main chimney was such a major element of this house, that says a lot." Whether this chimney came down on its own remains a mystery. If it collapsed, however, it would have been a newsworthy event on Capitol Hill, with tons of brick most likely tumbling right into the street.

Another captivating design feature of the house is the turn-of-the-century stained glass. In many of the rooms, small, decorative panes above the

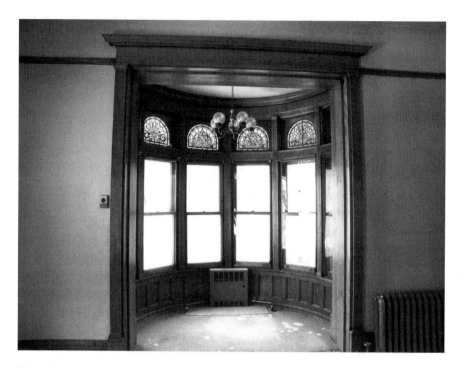

Original stained-glass windows accent the "sunroom," located on one end of the library.
Photo by Ann Alexander Leggett, January 2011.

clear glass central windows add to the Victorian ambiance of the mansion. Epitomized by the enormous stained-glass windows still in place above the main interior stairway and illuminating the second-floor landing, the windows add a delicate and feminine touch in poignant contrast to the cold stone exterior. Though not all of the original windows are still in their frames, those that remain continue to cast warm light, filtering the bright Colorado sun through amber and rose-colored panes.

In 1976, four of the fabled stained-glass windows were stolen from the mansion. The four windows were worth an estimated $30,000, and the owner at the time, Trenton Parker, desperately offered a $10,000 cash reward for their recovery. Astonishingly, the windows turned up—a mere four days after being ripped right out of the mansion walls—in an antique store a few miles away on South Broadway. The store's owner, Bruce Stowe, later reported that "four well-dressed men" had brought the windows in, asking $300 for the set. After some hard bargaining, the thieves departed with a check for $250, and Stowe chalked up a shrewd purchase. However, when

friends informed him of newspaper reports of stained-glass windows having been stolen from a Capitol Hill mansion, Stowe reluctantly but dutifully called the police. Very soon, the windows were on their way back to their home at the Croke-Patterson.

According to previous residents, that wasn't the only time original windows were stolen from the house. Today, many of the smaller stained-glass panes remain above the larger clear windows, but in the main entryway, where a multicolored wall of windows once cast a charming glow over the room, only four large stained-glass panels remain. Other windows have been replaced by modern translucent glass. A comprehensive inventory of the mansion completed in 1973 for the National Register of Historic Places mentions additional stained-glass sidelights on each side of the front door. Sadly, these too are now missing.

During the 1960s and '70s, the trend toward urban renewal and multi-unit housing was rampant, and yet, with the persistent efforts of a woman named Mary Rae, the Croke-Patterson Mansion was accepted onto the National Register of Historic Places. A few years earlier, Historic Denver, Inc., had been founded, in part through citizens' efforts to save the famous Molly Brown House, just a few blocks away from the Croke-Patterson Mansion. Dedicated to maintaining the integrity of Denver's historic neighborhoods, this creative preservation organization quickly took the reins in guiding the future protection of Croke's legacy.

Designation as a National Historic Landmark in 1973 considerably brightened the future of the Croke-Patterson Mansion. As other historic Capitol Hill mansions were being demolished left and right to make way for apartment buildings and parking lots, the Croke-Patterson managed to dodge yet another bullet. The prestigious neighborhood had witnessed change, both welcome and otherwise, from its earliest inception. As early as 1908, in fact, maps show that a large apartment building sprouted up on the block immediately to the northwest of Croke-Patterson, a development that must have made Thomas Patterson wince.

Historic Denver is presently the holder of a $300,000 easement on the Croke-Patterson property, thus ensuring its continued preservation. "It's a triumvirate of protection," says John Olson. "It's a local landmark, it's on the National Registry of Property and there is an easement in place." With landmark status, no exterior alterations can occur that may diminish the historic integrity of the house. However, the rules still allow for the interior to be altered, and in recent decades, the results of much poorly conceived remodeling have been witnessed.

These days, however, the exterior masonry is the organization's primary concern. In theory, the stone will retain its integrity, for the most part, with problems arising particularly when attempts are made to patch it. Over the years, several repairs have been made with concrete and mortar patches, which, despite the best of intentions, actually caused an accelerated rate of deterioration. The sandstone is so permeable that attempting to cap and seal it with a harder material only causes the stone to retain moisture, inevitably leading to further decay.

By the mid-1990s, the stonework on the exterior of the Croke-Patterson Mansion had declined to the point where it was obvious that aggressive conservation would be required. In 1997, James Wollum and Associates conducted a meticulous stone-by-stone study, using elaborate scaffolding to take an intimate look at every single stone block on the façade. They identified problem stones, with the goal of determining the overall extent of the damage. The conclusion was inescapable: the house was in bad shape.

Saving a historic structure is not only a matter of identifying its weaknesses. In 2001, in an effort to take inventory of which stones were still

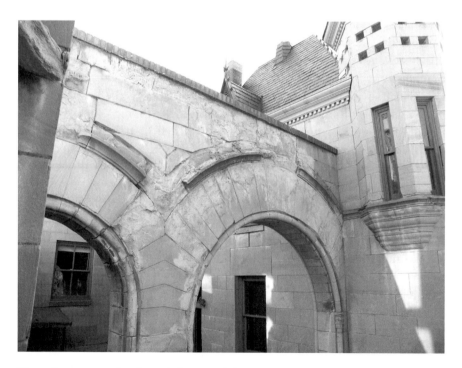

The archway connecting the main house and the carriage house shows attempts made to repair the deteriorating stone. *Photo by Ann Alexander Leggett, April 2011.*

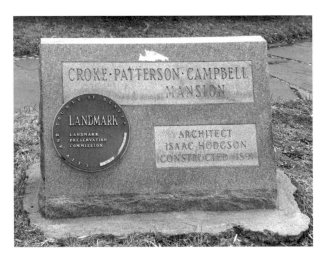

The historic marker for the Croke-Patterson Mansion is located on the hillside in front of the house. *Photo by Ann Alexander Leggett, February 2011.*

sound, the firm of Atkinson-Noland and Associates conducted yet another study. Again in 2009, at Historic Denver's request, the firm provided a letter outlining the condition of the stone based on a brief reevaluation. The specialists were surprised to find that since the 2001 study, the deterioration had not proceeded at the alarming rate they had expected. Regardless of these professional evaluations, it is evident even to the untrained eye that the exterior structure of the Croke-Patterson Mansion is in need of extensive restoration. Previous patches are unsightly, and the stone crumbles when touched. A pile of fallen stone in the backyard is a sad testament to the state of the exterior. With a new roof installed in the past few years, as well as improved landscaping, many emergency issues have been addressed. Drainage problems that caused some of the sinking and damage at ground level have been mitigated. Overall, however, there has not been a lot of work done on the house.

In many areas, the interior of the house is still as impressive as ever. The main floor in particular retains much of the grandeur of its early years. Mahogany trim, much of it painstakingly restored by Mary Rae during her ownership, is still in good shape. Many of the fireplaces still have their tiled hearths and elaborate mantles intact and look surprisingly unchanged when compared to photos from the Patterson years. The office renovations in the 1970s, however, took the heaviest toll on the mansion.

When we walked through the house with Mary Rae, she immediately noticed and lamented the many alterations to the house. The office conversions had brought in glass divider walls and makeshift kitchens. Some original walls were removed and other walls added. One large room

holds incongruous wall-to-wall white wire shelving. The carriage house was completely transformed during these renovations and now boasts curved interior walls in a nod to 1970s design trends; it certainly doesn't resemble its original state. Over the years, the carriage house has evolved from a barn housing horses and feed to a car garage to a neglected storage unit of sorts. Intriguingly, the heavy hayloft door and steel ridge beam, the subject of so many lurid rumors, are still in place on the upper floor.

According to Olson, up until the 1950s, the owners and residents did a pretty good job of maintaining the property, just by virtue of living in it. Unfortunately, diminished use means diminished maintenance. Since the mansion has stood empty for so many years, it now screams for attention— as do the spirits that reside within its walls.

BABIES IN THE BASEMENT

Every ghost story about the Croke-Patterson begins the same way: a new house, a young couple, a child. The story echoes like a timeless and idyllic fantasy, a tale to tell the grandkids. And everything is perfect. He, the model businessman, returns home at 6:15 p.m. every day to a meal that she, the devoted housewife, has lovingly prepared for him. They live in a red stone castle straight out of a fairytale, on a tree-lined avenue in a beautiful neighborhood. Not just any neighborhood, but *the* neighborhood—the enviable hilltop realm of the up-and-coming elite of a young and vibrant new city. The self-made man rules his castle. The wife and child spend their days singing and playing in the mansion's many sunny parlors. And life is a dream.

And then one day, the child dies. Perhaps an especially nasty infection was rampant at the time, the child was born sickly or the cold winter weather took its toll; the particulars are not important. Whichever way the dice fell, the fairytale was no more. The husband came home later and later in the evening, sometimes never coming home at all, and the wife spent more and more time sitting in the front parlor, staring out the window. The child had been buried at a cemetery not too far from the house, and that was the direction of her sad gaze, as if from where she sat she could see her child.

One evening, the husband was due home late. His reason was a business dinner, he might have said, but whether this business was done at the bottom of a bottle or in the back of a bar, his wife no longer cared. She left the house with a sense of purpose, a grim confidence that grew with every step she

took. Though she stumbled slightly in the darkness, she made the long trek to the cemetery and swiftly located the small mound of earth that marked her child's tiny grave, as though she had made the journey a thousand times before. Slowly, but without hesitation, she began her work.

When the husband returned home in the small hours of the morning, he may have found the front door slightly ajar. Or perhaps he awoke to an empty bed. It may be that he suspected nothing was amiss until he came downstairs to enjoy his breakfast and found the table bare and the stove cold. Whatever the details, the premise is the same: something was not right. There was a quiet stillness about the house, as if time had stopped. Perhaps on the way to his basement study, as he walked past the grand mirror on the main floor, the husband felt the hair on the back of his neck stand on end. Regardless, he found himself making his way down the stairs and around a corner, strangely drawn to the back basement room. Imagine his uneasy curiosity when he found a hole in the bricks, something smaller than a fireplace and roughly done, as if an animal had somehow maneuvered a section of the bricks out of place. Leaning down to the hole, he peered into the darkness, recoiling in shock when he discerned a small, pale hand poking out of the sand and ash filling the space between the walls. Horrified, the man staggered backward and ran upstairs in search of his wife. There, in the confines of the small tower room, he found her lifeless body.

The wife was buried, the child reinterred and this version of the story ends there. No mention of the husband, or of the house, aside from the obvious conclusion: the woman still walks the halls and sits at the window, weeping for her child. The cries of the motherless child echo in the back hallways at all hours of the night. And this is just one thread of the tangled network of rumors that surrounds this house.

Of all the research that went into the writing of this book, by far the easiest part was finding the rumors and the folklore. In fact, they were inescapable. Straightforward history, on the other hand, which should have been cut-and-dried, proved elusive and half buried in pseudo-facts and perpetuated myths. The Internet abounds with flight and fancy about this house, and sorting the truth from the tall tales was our greatest challenge.

There are a few central stories about the house that have snowballed into the storm of rumors and third-hand "experience" that is now splattered across the Internet. Most of them can be traced back to this tale of the grieving mother, yet in the records of the house, we find no evidence of such a family. There are deaths and suicides, yes, but nothing that definitively points to this specific event. Nevertheless, any basic search for the Croke-

Patterson Mansion yields this story in some form or another. Far from taking place during the earliest days of the mansion, the story does have a small root in events that took place in the early 1980s, when the building was broken up into offices.

Disturbed by reports of babies crying in the night and sounds of early morning partying, the owners took it upon themselves to bring in a psychic, on Halloween night, to hold a séance. This story, too, is often debated. The details vary, but the bare-bones version goes like this: during the séance, the medium claimed a woman had taken her own life in the house. That much is actually true. Tulleen Sudan, Dr. Archer Sudan's wife, did kill herself in the house in 1950, using a combination of rat poison and water to create a lethal gas—it's in the public record. The medium also reported that someone was buried in the basement, behind a wall in the back corner of an unfinished room. The participants ran downstairs and tore the bricks out of a portion of the wall—only to find, well, nothing. (Or, in some accounts, inexplicable sea sand or even ashes.) What exists in that hole in the present day is a mixture of ashes and sand, but then there are half-empty sacks of construction sand all over the basement. Various hosts of haunted house tours or wannabe ghost hunters tend to replenish the sand in the hole around Halloween every year, to heighten the mystery, and it appears that no one goes to much trouble to hide the evidence.

The trouble with this account is the staged séance. Self-proclaimed psychics abound in our society, and while some appear right off to be obviously fraudulent, there are many who are legitimate. They may indeed be able to communicate with the spirits of the deceased, and they may have some insight into what happens after death. Without exception, the psychics and sensitives we worked with on this project were intelligent, caring and talented individuals, who greatly contributed to our understanding of the Croke-Patterson Mansion. Unfortunately, as Bryan Bonner of the Rocky Mountain Paranormal Research Society puts it, "you can't use something that hasn't been scientifically proven to scientifically prove something else." Therefore, no matter what evidence psychics might contribute to an investigation, if the investigators are relying on purely empirical data, the psychic channel cannot be considered conclusive.

Another tale often repeated regards the construction that took place in the 1970s. There was an issue with the progress on the building: every night, tools and materials were disturbed and work undone, to the dismay of the work crew arriving in the morning. Some people immediately blamed the house and its ghostly inhabitants, but many assumed it was due to the

population of the homeless and vandals in the area. So, the owners hired a security guard. As it turns out, the guard was something of a flake and was soon replaced by a few guard dogs and a fence. Fences don't mean much to trespassers, but dogs do, particularly when they are of the Doberman or German shepherd breed (the breed varies from story to story). On their first night in the house, however, two of the dogs threw themselves out a plate glass window on the third floor, and the third was discovered the next morning, shaking and drooling in a puddle of its own waste. Creepy, right?

This story has root in truth, actually. Most of the beginning is true, right up to the dog part: only two dogs were ever in the house, and they were German shepherds, according to our sources. One dog exited through a small window on the first night, and the second dog followed suit the next night. The owner of the house at the time witnessed evidence of this, and a paranormal investigator spoke to a workman employed there at the time who corroborated the account. The dogs did in fact leap (or were thrown) to their deaths through the small curved-glass window on the third story of the tower. To this day, no one knows why. Just what the paranormal bloggers find so appealing about a mythical third dog, "mercifully spared, but shaking and drooling in a puddle of its own waste," is also unknown, but it's a line often repeated in descriptions of the history of the house and one that should be deemed untrue.

Over the years, a slew of amateur ghost hunters, sensitives, realtors specializing in novelty properties and people just looking for a little attention have reported more and more "firsthand accounts" of hauntings at the Croke-Patterson Mansion. Taking on a life of their own, the tales have snowballed at a pace that rivals the myths surrounding the Stanley Hotel in Estes Park, the infamous setting of the cult film *The Shining*. What once were tales rooted in history, with some minor hyperbole, have blown up into a maelstrom of the sinister and bizarre.

One such report is possibly a gross misrepresentation of an event that occurred in the late 1800s, associated with what is now Cheesman Park, less than a mile east of the Croke-Patterson Mansion. The park was a cemetery in those days, and rumor has it that the undertaker once inhabited the carriage house of the Croke-Patterson Mansion and used it as his mortuary. More sinister still, the deranged "Willie" reportedly kidnapped people from the main house and transported them to his lair via a tunnel that ran beneath the foundations before torturing and murdering them. Some tales even elaborate on satanic rituals being performed on the hapless victims, after which the bodies were chopped up and secretly dumped.

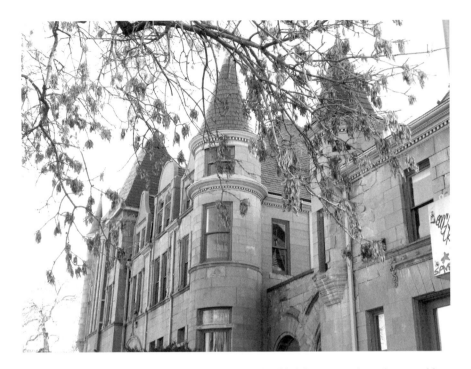

Many of the rumors of hauntings are centered on the third-floor turret (tower) room with the small curved-glass window. *Photo by Ann Alexander Leggett, January 2011.*

The climax of this particular vein of tales usually involves the vicious murder of a small boy whose corpse was then hung by the evil mortician in the tree out front for the entire world to see. In other versions, the child's body was hung from the steel beam in the carriage house, and when one stands beneath the beam today, it is said that "you can feel Willie's icy grip encircling your neck!" Again, absolutely no historical record of any of this exists. The carriage house was typically reserved for horses and hired hands, not rented out to homicidal undertakers.

The most enduring tales always have a kernel of truth. The very real event that may have led to this outlandish anecdote took place in 1893. The City of Denver was weary of the eyesore that the cemetery had become. By 1886, what had originally been Mount Prospect Cemetery/Prospect Hill Cemetery had been broken up into distinct sections. Mount Calvary, a separate and well-kept Catholic graveyard, shared a border with the newly renamed City Cemetery, the Jewish cemetery and Morgan's Addition, some of the most expensive real estate in the city. While Morgan's Addition grew

into a prestigious neighborhood, and the Jewish and Catholic cemeteries were lovingly attended and groomed, the City Cemetery had not fared so well. What was to have been a burial ground for Denver's rich and famous was instead filled with the graves of paupers, immigrants and the diseased; what should have been a beautifully kept memorial park was, in fact, a tangled mess of weeds and toppled gravestones. Grave robbers and pranksters had their pick of the bodies in City Cemetery and often left their prey hastily reburied or uncovered altogether, creating a ghastly minefield of empty pits and corners of coffins poking up through the ground.

The City of Denver decided in 1890 that a municipal park would be a better allocation of the land and announced a ninety-day window for families to move the remains of their loved ones to other cemeteries. These included Riverside Cemetery on the bank of the South Platte and even the older Mount Calvary Cemetery, though it was soon to be closed to burials in order to cede to its newer counterpart, the brand-new Catholic Mount Olivet Cemetery in Jefferson County. It was decided that the park would be named Congress Park, after the act of Congress that finally rid the city of its thorn, but the question remained of how to relocate the land's deceased inhabitants. An undertaker by the name of E.P. McGovern, then the superintendent of Mount Calvary, was contracted to move the bodies to Riverside Cemetery.

A low-lying plot of land that once attracted Denver's earliest investors, and which had experienced much industrial growth, Riverside had a tendency to flood whenever the South Platte ran too high. Essentially a riverbank, the cemetery was nevertheless chosen to receive the relocated remains, and a good portion of the unwanted bodies from City Cemetery wound up there. What was once a "sad plot of land" is today Denver's longest-operating cemetery, though it stopped receiving burials in 2005 and has since run out of funds for maintenance.

The logistics of disinterring and moving the contents of an entire cemetery must have been a daunting challenge. Each body was to have "a fresh box," and the undertaker was to be paid a little under two dollars for each corpse that he moved. Rumor has it that McGovern, being a shrewd if unscrupulous businessman, quickly saw a better way to increase his earnings, so he used child-sized coffins, cutting up each body and using two or even three boxes for each set of remains. Though some have ascribed the lack of adult-sized coffins to "a mining accident in Utah," to which Denver had helpfully sent supplies, once again the historical record does not add up. The nearest record of a disaster for which Denver shipped coffins and

supplies anywhere was the Scofield mine disaster, which indeed happened in Utah and killed over two hundred miners—in 1900. Since it is unlikely that McGovern anticipated that tragedy by seven years and preemptively shipped a couple hundred adult coffins off to Utah, yet another Internet tale bites the dust.

More likely, there simply weren't enough coffins of any size to accommodate the enormous task. What began as a simple relocation of thousands of human remains quickly became a macabre hacking up of corpses to fill every coffin available. His motives are under some dispute, as E.P. McGovern was a well-respected undertaker in the community and a Catholic himself. It could be that the desiccated remains simply fell apart during disinterment, and in the haste and confusion, the bones were chucked into the nearest box. Whatever the means or motive, the ante-mortem butchering left a trail of body parts and coffin wreckage across the cemetery for all the city to see. The Chinese section of the cemetery was exhumed by the residents of the "Hop Alley" area of Denver, with the intent of sending the remains of their loved ones back to China. The bones were stripped of any remaining flesh and clothing right there in the cemetery so they could be cleaned and wrapped for transport. Done by the families themselves, and not by trained undertakers, this only added to the macabre scene.

The *Denver Republican*, a popular newspaper, published an article about the morbid spectacle five days after it began. "The Work of Ghouls!" hit the press on March 19, 1893, and described the scene as such:

> *The line of desecrated graves at the southern boundary of the cemetery sickened and horrified everybody by the appearance they presented. Around their edges were piled broken coffins, rent and tattered shrouds and fragments of clothing that had been torn from the dead bodies…All were trampled into the ground by the footsteps of the gravediggers like rejected junk.*

It is probably unnecessary to say that when the Health Commission began an investigation, McGovern was fired. Bizarrely, his gruesome handiwork was never cleaned up, and the job remained unfinished. Another contract to move the bodies was never awarded, due in part to Riverside Cemetery's failure at the time to meet either the Health Commission's standards or those of anyone else, for that matter. Empty graves pitted the landscape for over a year until the leveling for the park began, a process that took more than a decade. While the park was finally completed in 1907 and designated Cheesman Park after a donation by Walter Scott Cheesman's

family, the remaining bodies were never moved. As a result, Cheesman Park still holds the bones of some two thousand souls, many of whom are probably upset with the arrangement; the park is purportedly one of the most haunted in the United States. This graphic and disturbing chapter in Denver's history has been bastardized over time to include ghoulish inventions of Croke-Patterson's possible ties to Cheesman Park. They are inventions, and nothing more.

Of all the rumors swirling around the mansion, by far the most prevalent one is also the most brief. Thomas Croke walked into his brand-new house upon its completion "and was so shaken by the experience" that he turned and walked out, never to return. Thankfully, this rumor was also one of the easiest to clear up. The owner subsequent to Croke, Thomas Patterson, bought the house in 1893 without so much as discussing it with his wife, who was in Boston at the time. He did, however, write her a letter detailing the fabulous deal he had negotiated and the circumstances under which he had purchased the house. According to this letter, Croke actually had inhabited the house, though only for about six months. While some hold fast to the notion that the house itself was uninhabitable to Croke, there are several other factors that more likely played a hand in his decision to relocate. First, and probably foremost, Croke lost his first wife a short time before he began to plan the house. He kept moving forward in his plans, but shortly after he and his parents and children had moved into the mansion at 1075 Pennsylvania, his mother, Mary, died as well. Adding insult to injury, a final tragedy struck in 1893 in the form of the Silver Crash.

Croke was destined to lose much of his fortune in the Panic of 1893, which would be, prior to the Great Depression, the worst financial collapse ever to occur in the United States. The Sherman Silver Purchase Act of 1890 required the federal government to buy several million ounces of silver to back the nation's currency. Simply stated, the act had the immediate effect of driving up prices. Benefiting the most were farmers pushing for inflation to alleviate their debts, and miners pushing for silver scarcity to artificially drive up the market price. However, overbuilding and speculation created a bubble of prosperity that was perhaps nowhere more fragile than in the booming city of Denver.

Many previously secure, up-and-coming gentlemen lost their life's savings in failed ventures. Suddenly unable to meet their mortgage obligations, many were forced to walk away from recently built homes, a scenario that was particularly rampant in Denver's Capitol Hill neighborhood. An unfortunate number of Croke's contemporaries, including the original owners of the

famed Molly Brown House, took tremendous losses on palatial homes similar to his own. Croke at least had the opportunity to trade his city home for ranch land, something he could hold on to through the panic. He retired there, where he kept himself busy with his second wife, their seven children and his various community and business endeavors.

All in all, this house is often on the minds and in the conversations of Denver residents, as well as being a favorite subject in paranormal circles. Whatever degree of truthfulness the many tales might contain is not always readily apparent, but there is no question that the storytelling will continue. The Croke-Patterson Mansion has a rich history and does make for good rumor fodder. As spectacular stories continue to circulate, both verbally and online, the focus of this manuscript is to lay to rest the ones most lurid and untrue. It has been our endeavor to restore the dignity of this house, while allowing it to retain its eerie grandeur.

A Good Trade

In a letter to his wife, Katherine Grafton Patterson, as she traveled on the East Coast with the children, Thomas Patterson made an announcement that may have come as something of a shock. He had traded, without consulting her, a decent portion of his landholdings in return for a mansion on Denver's Capitol Hill. The house, which he estimated to have been constructed for $40,000, was newly built and came fully furnished and carpeted, at the cost of 1,440 acres of ranch land near what is today the city of Northglenn. The letter reads as follows:

> *Denver Feb 4, 1893*
>
> *My Dear Kate—*
>
> *I traded the ranch and some other property off for a home on Capital* [sic] *Hill—Corner Pennsylvania + 11ᵗʰ Aves. The ranch was the bulk of what I gave in exchange. The house is new—cost about $40,000, of red stone + very pretty. It's not such a house as you + I would build. There is a splendid stable and the person who built it thought it was ne plus ultra. I traded with Mr. Tom Croke—the Carpet man. He built it. The rooms are all carpeted—bran* [sic] *new. His father + he have occupied it for about six months. The reasons I traded were: The ranch had become a burden—Jones, the owner of the other half, unbearable, I had to have a home when you + the children returned—which I would be compelled to rent for a very uncertain + I fear a very long time. I hope you'll like it. I think you will. I know the girls will.*

Now, if your breath's not taken away, what do you say? When will you be likely to return? I don't want you to come back until you feel your health is secure. I think a change to Denver would be good for Mamie at least for the Spring + early Summer. Maud—she's tough, she's healthy anywhere.

You can reflect on this—I'll say no more now.

Love + kisses to the girls. With great love + in haste, I am

Your Affectionate Husband

T.M. Patterson

This letter provides the most solid evidence yet pertaining to how long Croke occupied the house he built, thus disproving an enduring myth. Discovered in the Patterson Collection in the University of Colorado Archives, this small pearl of straight-forward history was quite unexpected after wading through so many contradictory accounts of the mansion. In a couple brief but revealing disclosures, we learn not only how much the house cost to build but also that the transaction included new carpet in every room. Patterson found its construction to be "the highest achievement," as he noted in French. It is tempting to speculate just what sort of house he and his wife might have built themselves, given the time, but Patterson was clearly pleased with his acquisition.

As an informal exchange within a long marriage, it also provides an interesting glimpse into the Patterson family dynamic at the time. Katherine, in charge of their children while her husband immersed himself in his political career, found herself traveling quite a bit during the end of the nineteenth century. Tragically, their firstborn son, James, had suffered from depression and committed suicide in 1892, at the age of twenty-six. Mary (who went by Mamie) was often ill, as was Kate herself, and so mother and daughters traveled throughout the United States and Europe searching for somewhere they could regain their collective health. The baby of the family, Margaret, referred to as Maud more often than not, was "healthy anywhere" and ended up being the only Patterson child to survive through to the end of the 1890s. She and her husband, Richard C. Campbell, would end up residing in the mansion the longest of any of its occupants. But it all began with Thomas Patterson.

Thomas MacDonald Patterson was born in County Carlow, Ireland, in 1839 to Margaret Mountjoy and her husband, James Patterson, an Irish watchmaker. He had two siblings—a sister, Catherine, and a younger brother, James—and when Thomas was ten years old, the entire family moved to New York City. They spent a short time there before moving to the suburb of

The letter from Thomas Patterson to his wife, Kate, describing the purchase of his new mansion, 1893. *University of Colorado at Boulder, University Archives (Thomas Patterson Collection, Box 3, Folder 18).*

Astoria, New York, and lived for four years there before relocating to Crawfordsville, Indiana.

After a brief enlistment in the 11th Indiana Infantry in the Civil War, during which he lost his brother James at the Battle of Winchester, Patterson enrolled at Asbury University (now DePauw University), where he studied law. He excelled at all subjects except math and thus sought a tutor in that subject, in the form of Miss Katherine Grafton of Wellsburg, West Virginia. Having attended college in Jacksonville, Illinois, Kate had moved to Indiana to teach in preparation for a missionary position in India. She ended up tutoring Patterson in mathematics, and they were married in 1864. Their first child, James, was born in 1866, and in that same year, Patterson began to work in a local law firm as a clerk.

He passed the bar in 1870, three years after the birth of their first daughter, Mary, and shortly before the birth of their third child, Margaret. He became increasingly involved in politics and public speaking and traveled quite often for legal business. As a Democrat, however, he found himself struggling in Republican Indiana, and he began to look to relocate his family, both to further his career and to stabilize his

wife's fragile health. After some consideration, he settled on Denver, a prime venue for a politically ambitious lawyer. The location also touted health benefits and sunny days, so he purchased some land and sent for his young family in December 1872.

Despite his obvious talent, Patterson's initial employer, the staid firm of France and Tofer, actually let him go, perhaps finding the young man's brash style disagreeable. As a young and vigorous lawyer, Patterson quickly became associated with Charles S. Thomas, another well-established attorney in the city. A better personality match, Thomas and Patterson soon opened a one-room law office on Holladay, now called Market Street, not far from the

Katherine Grafton Patterson, circa 1886–1901. Katherine was active in the women's suffrage movement, helping Colorado women win the right to vote in 1893, over a quarter century before equal suffrage existed nationally. *Photo courtesy of Denver Public Library, Western History Collection, Rose and Hopkins, #H-76*

small house Patterson built for his family on Welton. Although Patterson was often required to make the journey back to Indiana to finish up cases there, he quickly gained status in the booming city of Denver. He became renowned for his aggression both in the courtroom and during his political speeches, a reputation that would mark his entire career, although many accused him of cockiness or even downright vindictiveness.

In his pursuit of business and political advances, Patterson was often away from home for weeks at a time, a habit that greatly affected his relationship with his wife. Both shy and in poor health, Kate was unable to socialize in the manner of Denver's elite hostesses, and her husband's frequent absences sharply punctuated her loneliness. Shortly after their fourth child was born in 1874, the infant died, causing her to plead with her husband to return home and stay. Unfortunately for her, in the broiling political climate that was leading so many prominent citizens to push for statehood, Patterson saw his chance to gain public office as the Democratic territorial delegate to Congress.

After running for the position and winning, Patterson found himself heading up efforts to make Colorado a full-fledged state. His tireless campaign for statehood did in fact meet with success when Colorado became the Bicentennial State in 1876, but unfortunately for Patterson and his Democratic colleagues, the new state ended up casting all its electoral votes toward Republican Rutherford B. Hayes, who became president solely because of those votes. Undeterred, Patterson became very active in Congress between the years 1877 and 1879 as a member of the House of Representatives and, later, as a United States senator for one term, from 1901 to 1907.

Tom and Kate's second son was born early in 1878, but little Thomas survived only through the spring of 1880, dying of influenza while Tom was away on business. Family life became increasingly strained as Patterson's career soared and he was required to travel more and more often. Katherine even went so far as to request a separation. Beginning in 1881, she took the children to Europe for three years. Though distressed both by her attempted divorce and by his father's death, Patterson continued to push forward in his career. His reputation as a talented litigator was on the rise, and soon he was winning every case he came up against.

In 1890, Patterson acquired a majority of the shares in the venerable Denver newspaper the *Rocky Mountain News*. He essentially walked away from his law practice and began devoting his life to the newspaper, a passion that would get him into occasional trouble, as people often found

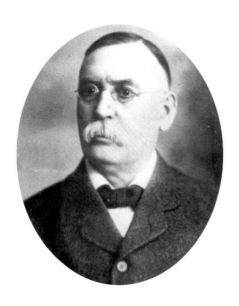

Thomas MacDonald Patterson as a U.S. senator, circa 1901. *Photo from* Representative Men of Colorado.

him to be a little "too honest" and barbed in his criticisms. He built up the headquarters of the *News* at 17th Avenue and Welton Street, very near where he had once lived. In 1892, after news came from California that James had committed suicide by an overdose of codeine, Mary and Margaret traveled to retrieve their brother's body. Devastated, Katherine then took the girls with her to Boston for her own health and that of her older daughter, Mamie (Mary). It was around that time that Patterson was moved to trade his land for the mansion on 11th and Pennsylvania.

Sadly, Mary wasn't strong enough to enjoy the house for long; she succumbed to her chronic illness in late 1894, leaving the Pattersons with one surviving child, Margaret (Maud). It is interesting to note that our research never uncovered a definitive cause of death for Mary, nor could we find a death certificate or obituary, which is rather odd given the fact that Mary was the daughter of a prominent politician, attorney and newspaper owner. Personal correspondence to and from Thomas Patterson only refers to issues with her hearing and "ill health." In their grief, Thomas and Katherine withdrew for some time after Mary's death, leaving Maud to deal with the day-to-day affairs of the mansion. It was during this time that a distant cousin came to town and caught Maud's eye, but out of respect for her parents' mourning, they waited until a full year had passed to marry. That cousin was Richard C. Campbell.

In the aftermath of the Silver Crash of 1893, it can be assumed that Patterson lost at least some of his wealth, but he had managed to secure the Croke-Patterson Mansion before the market collapsed that summer. His newspaper career continued through the crisis and into the twentieth century as he took the side of the state's Populists, criticizing the Colorado legislature's seeming inability to do anything productive. His pointed critiques often got him in trouble with powerful men in Denver, including

but not limited to fellow newspaperman and part owner of the rival *Denver Post*. Frederick Bonfils went so far as to physically attack Patterson in the street, with a cane, in 1907. Before he came to blows, however, Patterson had been struck with yet more personal tragedy.

Katherine died in her bed in the Croke-Patterson Mansion in 1902, after a long career of loving her husband from afar. She had endured the deaths of all but one of her children and did not live to know her grandchildren. She had acted as her husband's hostess and campaigned quite firmly for women's suffrage in the Denver community. A newly minted U.S. senator at the time, Patterson mourned his wife and, perhaps made aware of his own mortality, deeded the mansion to his only surviving child, Margaret Patterson Campbell, for the sum of one dollar. He resided there with Maud and her husband, Richard, and their children until his own death in 1916.

In his remaining years after Katherine's death, Patterson managed to remain quite busy. He ran for governor of Colorado twice (though he lost both

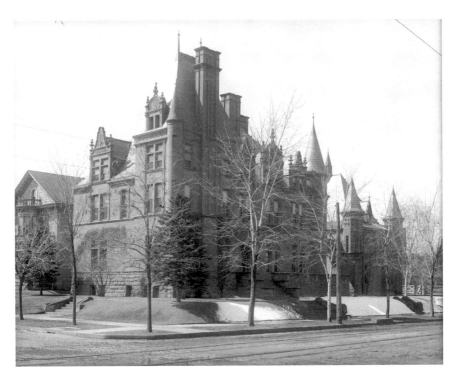

The Croke-Patterson Mansion in 1908, with the Pattersons in residence. *Photo courtesy of Denver Public Library, Western History Collection, Louis Charles McClure, MCC-444.*

Thomas Patterson with his daughter Margaret in front of what we believe to be the now-missing fireplace in the front parlor, 1905. *University of Colorado at Boulder, University Archives (Thomas Patterson Collection, Box 8, Folder 1).*

Left: Thomas Patterson with his beloved grandson Thomas Patterson Campbell near the front door of the mansion, 1897. *University of Colorado at Boulder, University Archives (Thomas Patterson Collection, Box 8, Folder 1).*

Below: Margaret Patterson Campbell and her son Tom in a carriage outside the mansion. *University of Colorado at Boulder, University Archives, (Thomas Patterson Collection, Box, 8 Folder 3).*

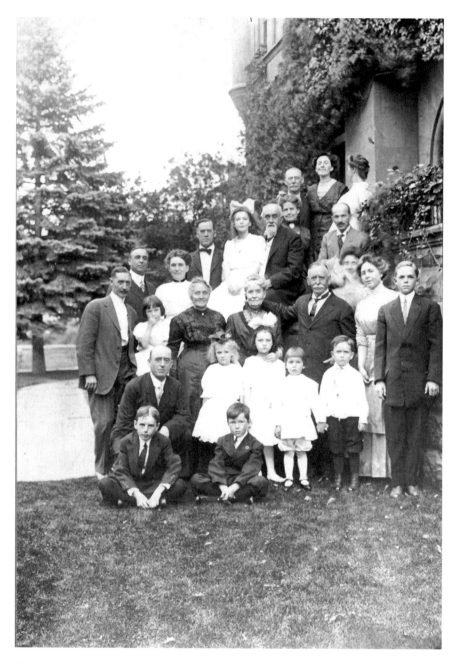

The extended Patterson and Campbell families on the steps of the mansion. *University of Colorado at Boulder, University Archives (Thomas Patterson Collection, Box 8, Folder 12).*

times) and continued to fight political corruption and publish harsh truths in the *Rocky Mountain News* until he sold the paper to John Schaeffer in 1913. He delighted in entertaining his grandchildren whenever they were around. According to Sybil Downing, Thomas Patterson's great-granddaughter and biographer, Margaret seemed to be Patterson's least favorite child. However, she did provide Tom with his three beloved grandchildren. Thomas Patterson Campbell was born in 1896, and Richard Jr. and Katherine followed in the early twentieth century. After a long and prosperous life, Patterson suffered a stroke as he was leaving his office and, although he made his way to the mansion unassisted, he died in his bed a few weeks later.

Maud and Richard spent many long years in the mansion, from their wedding in its library in 1895 through 1924, when they invested in a more modern home off York Street. A look back at the Capitol Hill of the 1920s reveals that it had become less exclusive than it once was. Denver historian Amy Zimmer describes longtime residents lamenting, "It no longer implies the social leverage of a few years ago when you were either on it or not on it…and, indeed, one can no longer tell just who you are by where you live." Apartment complexes for the working classes were springing up left and right in the formerly stately neighborhood. With advances in transportation making it easier for the well off to connect with business and society from farther away, the city's upper class no longer needed to be within a few blocks of downtown.

Maud and Richard died in 1929 and 1930, respectively, and with the sale of the house in 1924, and their deaths, we close the Patterson-Campbell chapter of the mansion. From that point forward, the house was occupied by various offices, schools, companies and apartment dwellers, each leaving behind its own unique, if not exactly cohesive, footprint on the house's history. The mansion would not be a private single-family residence again until 1998, when the Ikelers took it over and reunified the building. While the interim years brought many changes and varied energies to the house, it can be argued that it was most likely the first forty years of the building's existence that formed the basis of the next eighty years of paranormal activity.

SOMETHING WICKED
THIS WAY COMES

The house was so cold, so mind-numbingly cold. Granted, it was February, and the house had been winterized for quite some time, but this cold was extraordinary. On this particular winter afternoon, I was there to get impressions from Krista Socash. Krista is a professional psychic healer, licensed minister and clairvoyant who had worked with me researching other haunted houses, but this was her first visit to the Croke-Patterson Mansion. The minute we entered through the deeply recessed and oversized front door, the chill hit us like a wall. "It's not just cold because it's February," Krista said. "No, this is about something else." Little did we know then how right she was.

When I called Krista to ask if she would be willing to do a reading on the house, she had been intrigued but had never heard of the place. She was up for the challenge, however. With directions coordinated into her car's GPS, and knowing only that the mansion was hard to miss—a massive structure of red sandstone on the corner of 11th and Pennsylvania—she set out to meet me. Two blocks away from the house, however, her GPS announced that she had reached her destination. Having no reason to believe otherwise, Krista looked up to see a large red brick and sandstone mansion. There was even a parking space waiting for her. As she had asked her spirit guides to help with the parking, which can be a nightmare in the neighborhood, she felt assured that she had arrived at the right place.

The owner found Krista wandering around the foyer, still thinking she was in the right place and meeting with me. Without introductions, he

immediately asked her what she thought of the place. "When I arrived at the house," Krista told me afterward, "I noticed it had a few lingering spirits but not much activity, so I said, 'It's ok,' and he looked at me blankly. I later realized he wasn't asking me about spirits, as he had no idea who I was at that time. He was asking me what I thought about the look of the interior. He worked in real estate."

It quickly became apparent to Krista that she had mistakenly landed on the steps of the nearby Grant Mansion, another historic Denver home. She told the man who she was and that she was meeting me to do a walk-through of a mansion at 428 11th Avenue. Knowing exactly which house she was referring to, he cheerfully offered directions to the Croke-Patterson Mansion. They laughed over the miscommunication and the fact that she'd pulled up to the wrong historic mansion, but as Krista told him, "There are no mistakes." She would later learn that the man's parents were good friends of her parents and that he knew her sister very well. This was just the first of many coincidences, if you choose to call them that, related to the making of this book.

When Krista drove up to the Croke-Patterson Mansion—to yet another rare, open parking spot—I was waiting outside. "Well, that was interesting," she said, and went on to explain why she was late. As I was thinking about her story later that day, I thought, "How could she get lost? She's psychic!" Well, I guess when your car's GPS says you have arrived, you tend to believe it, whether you are psychic or not. With Krista's visit, my most interesting time in the mansion would begin. While Jordan was immersing herself in archives and articles, I would tackle the house on this particular day, with Krista as my only companion. Indeed, this chapter is the record of my personal experiences that day.

Immediately upon entering the house, Krista saw the apparition of a woman standing on the main stairway, inviting us to go upstairs. "I see you," Krista said. "She's very sickly," she said to me. "Just really ill." The other thing that was readily apparent to Krista was the amount of energy in the mansion. She felt it wasn't so much a haunted house but a place with roaming energies, one of which she felt to be very dark. All the energy also seemed misplaced and scattered to her. "There is so much going on in here, on so many levels," she said. "So much that it's difficult to read it all. Yet it's not all connected. It seems to come not so much from within the house but from the land."

It was interesting to observe the physical and emotional reactions Krista had to the house. Male energy was predominant, she felt, and very strong and

oppressive. Also overwhelming to her were feelings of pain and sadness. As we moved from room to room, a hard-edged male energy kept coming back to her, distracting her and making it difficult for her to focus. At times, the energy even seemed to make Krista angry. She also kept seeing corruption of some sort and involvement with secret societies and political organizations. A strong connection to the railroad appeared to her as well. "This house has lots of secret passageways," she said. One of Krista's strongest impressions was that an early resident had suffered from sudden financial hardship. At that point in our research, we had not yet discovered the likely connection between the Panic of 1893 and Thomas Croke's abrupt sale of the mansion.

The woman on the stairs stayed put throughout our walk around the main level, and as a result, Krista referred to her often. "She is fearful of the people her husband brings into the house," she said. "Her husband was very prominent and had men come here to do business upstairs." However, there was also the energy of children in this main level of the house. Two young boys in particular made themselves known to Krista, one of whom had a name that started with a "T"—she felt the name was

The grand—and haunted—staircase leading up to the second floor. *Photo courtesy of Jane Carpenter, March 2011.*

Tim or Tom. We do know that Margaret Patterson had three children, including a son named Thomas. Other spirits on the main level seemed playful and acted as poltergeists, she noticed. According to Krista, they liked to play with the electricity in the house, and they also liked to bump people and move objects for fun. We hadn't even walked more than eight feet into the mansion and all of this was already apparent. The level of energy was very strong.

We struck out to do a complete walk-through of the house, level-by-level, room-by-room, with a small digital recorder running in Krista's hand. The main room to the right of the foyer struck Krista as being very sorrowful and heavy with crying and heartbreak. That room was, by contrast, one of the few rooms in the house that seemed very bright and happy to me. This would not be the first time we would observe distinctly different reactions among visitors to the house. The other rooms on that floor seemed to Krista to be rather quiet.

Then there was the mirror. On the left side of the main foyer, right above the staircase to the basement—which holds its own dark secrets—a huge mirror hangs on the wall. *There's something about the mirror.* There really isn't any good way to explain it except to say that most of the people who enter the house are immediately and inexplicably drawn to the mirror. The first time I entered the house, I, too, was drawn to it. I made several attempts to take pictures of myself in the mirror, which produced shots of a focused mirror and unfocused images of me. After several tries on subsequent visits, I finally got a somewhat clear photograph of myself in the mirror. My camera focused on my reflection in every other mirror in the house, but it refused to focus on me in that one. On that first day in the mansion, Krista went straight to the mirror and made the same pronouncement. "There's something about the mirror. It's wrong. It's *off.*"

As I do when I am researching a home by walking through with psychics or paranormal investigators, I kept my thoughts to myself and didn't mention that I'd had the same feeling. Many religions and cultures feel that mirrors are portals for spirits. Indeed, a traditional Victorian ritual during periods of mourning was to cover the mirrors in a house with black cloth to prevent the soul of the departed from being trapped in the mirror's image. Even older superstitions hold that looking into a mirror too soon after a death in the family would invite death to the survivors. Other visitors who accompanied us on tours of the mansion would probably agree that this mirror could be a portal to the netherworld. We're not sure how one could prove that, but this mirror is unsettling to be sure.

Author Ann Alexander Leggett is reflected in the large mirror on the main level. *Photo by Ann Alexander Leggett, April 2011.*

As we climbed the large stairway to the second level, the energy was relatively quiet—until we came to the bathroom to the left. Krista's reaction to this room was unnerving to me. She suddenly backed up and bent over a bit; she said she felt physically ill. "There is death in this room," she said. "Suicide." In all my time spent exploring houses with Krista, I had never seen a reaction of such intensity. In the weeks following that first day in the Croke-Patterson Mansion, our research would turn up countless stories of suicide, but at the time, Krista knew nothing of those rumors. There in that second-floor bathroom, the suicide that had been part of the mansion's folklore for so many years was making itself known to us. And the story was true: in 1950, a forty-seven-year-old woman killed herself in the house, and we were able to find her death certificate with the cause of death.

Retreating from that bathroom, we next entered the corner room to the right, which still has the remnants of some office conversion. As we stood in the doorway, Krista described the room as having been a man's office, where many people came to do business with him. The view from this room is a direct shot to the gold-domed state Capitol Building. I would later notice that at night the view is particularly beautiful, with the Capitol lights shimmering in front of the downtown Denver skyscrapers. We stood there, quietly taking it all in, when suddenly the floor began to creak as if someone were walking across the floor toward us. The footsteps seemed to stop right in front of me. "Is that me?" I asked Krista. "Am *I* making the floor creak somehow?"

"Nope," Krista replied with a wink.

And then came the sound from below. Something sounded as if it was being dragged across the main floor. It was the sound of something heavy combined with the sound of metal, perhaps chains. As clichéd as this may sound, there is just no other way to describe it. It was clearly coming from within the house. It thudded and suddenly stopped. Whatever it was, it was over.

As we were walking through the house, I took notes all the while, even though Krista's digital recorder was running. I couldn't be sure that the energies present would not interfere with the recording. My hands and fingers were stiffening with the cold, and my handwriting was beginning to suffer. Our breaths were visible in wispy clouds as we spoke. It was getting colder.

The third floor, the floor that I would come to learn is supposedly the most haunted, was next on our tour. The stairway twists and turns, and the steps seem as though they will give way at any moment. Krista went first and I followed. Upon reaching the top third of the last flight of steps, however, I immediately knew something was wrong. I felt my chest tighten. I struggled to breathe, and my heart pounded. My first thought was that I had been skipping the gym a few too many times recently, but when I reached the upper landing and saw Krista clutching her neck, I knew there was something else going on. "The woman who met us on the stairs on the main level…she wanted us to follow her up here," Krista said, struggling to speak. "She is so ill, and I'm feeling that she had a respiratory illness or heart trouble, because of our difficulty in breathing. She wants us to know that she was trapped up here, and that she really suffered."

This was a sensation that I had never experienced. Sure, I'd taken a flight of steps too fast before and felt the consequences, but this feeling took control of my body and even my mind. It shook my confidence in my own

strength, and it undermined my pride in being able to remain an objective observer to the energy in the house. The third floor was, in fact, completely different from the rest of the house. It was oppressive and heavy. I caught myself "seeing things," catching shadows and strange light out of the corner of my eye at every turn. I did not feel comfortable at all, and I had a strong urge to leave immediately.

The rooms on the third floor varied in their degree of unpleasantness. One of the rooms, I would later learn, had been the office of a veterinarian who had owned the home. This room seemed especially *heavy* to me, in many senses of the word. The air seemed dense, and it took effort to breathe. My body felt heavy, as if it were weighed down. At times, I labored to move, and my legs seemed to lack the energy required to take even a single step.

Off the central hallway, in the center of the third level, is a tiny room with a steeply dormered ceiling; it struck me as being particularly odd. I realized from its unusual shape that it was one of the rooms visible on the outside of the mansion as a small dormer, once elaborately framed in the Chateauesque style. With a dirty floor and bare walls dimly lit by a single window, the interior bore no relation to its impressive exterior. I would later learn that this room had a disturbing history of its own, with plenty of activity within its walls.

Of all the rooms in the mansion, we next entered the one that stands out the most and has been the root of so much urban legend: the tiny round room in the top of the tower. On the northwest corner of the mansion, the tower rises a dramatic three stories above ground level and is crowned with an equally impressive conical roof. It is, in architectural terms, properly a tower rather than a turret, as its base is connected to the building's foundation. However, almost everyone familiar with the Croke-Patterson Mansion habitually refers to the mysterious round chamber on the third floor as "the turret room."

The tower room and its small adjoining suite, which apparently was once used as a nursery, continue to be the subjects of rumor and speculation, all of which Krista was unaware of. On that day, standing in the room with her, I already knew of some of the legends regarding the space, but I kept them to myself to see where the room would lead her. No sooner had we stepped into the bedroom area than Krista recoiled a few steps backward. "It's really rough in here," she said. "There's energy of an angry young man."

I was standing still, silently nodding, when she abruptly asked if she could take photographs. She took her camera out of her purse and placed the purse on the floor at her feet. With the camera in her hand, not yet

turned on, she further explained her feelings about the room. Suddenly, her camera was pushed out of her hand, landing in her purse. "Nice try," she said as she retrieved it from her bag. To say that little act of aggression didn't bother me would be a lie. This did not seem to be the work of particularly playful spirits. Krista immediately handed me the recorder and tried to turn her camera on. It was dead. With our fingers nearly frozen at this point, we both attempted to reinstall the batteries and fumbled with the on/off switch. Nothing. Then, just as inexplicably, it turned itself on. I was nearly at a loss for words at that point, but Krista didn't miss a beat. With the camera now on she started to snap pictures, but the flash wouldn't work. Once again, we tried to find a reason for why the camera was malfunctioning. Not to be deterred, Krista resumed snapping pictures without even a glance at what she was shooting. And then, on about the sixth picture, the flash decided to work, without any further prompting from us.

The tower room is a most interesting space. The little room seems to draw some people in and repel others. I would later observe visitors walk over to it and immediately bend down to peer in through the small door, while others would simply recoil. This little round brick chamber, ensconced in the largest of the mansion's many towers and turrets, is entered via an intriguing child-sized door. The room was painted gold, not to mention carpeted in hot pink shag, by one of the previous owners, but the exposed interior of the conical roof reveals bare wooden rafters crisscrossing to a dizzying height. Large enough to fit only two adults at a time, the room has a curved-glass window overlooking 11th Avenue below. In earlier times, before the tall trees and apartment buildings, the view of the Capitol and downtown must have been spectacular.

This small door opens into the infamous turret (tower) room, which still boasts pink carpeting and gold walls installed by recent occupants. *Photo courtesy of Jane Carpenter, March 2011.*

The curved window has been the subject of some of the more lurid tales about the Croke-Patterson Mansion. Some say this is where another suicide took place, but the truth is that this is the window the two dogs jumped through, leaping to their deaths for no known reason. Over the years, the curved glass has cracked repeatedly, and in fact, the window was in a broken state the day I was there with Krista. Replacing the curved glass is expensive, as it must be custom made and fitted perfectly to the curved window frame. We read or were told various theories about the chronically cracked glass: it's the spirits of the dogs, of the woman who poisoned herself or of just about any restless body, either escaping from or returning to the mansion or simply creating mischief. But these rumors have little merit. Apparently, the stone lintel above that window is applying undue pressure to one side of the window frame, hence the continual cracking.

We were so cold at that point that we decided to get moving through the rest of house, so we walked down to the main level, where we were again drawn to the great mirror. What became even more intriguing was the cold spot directly in front of it. It's difficult to describe a spot that could be any colder than what we were already experiencing, but there it was, right in front of the mirror and very near the stairs to the basement. Krista said, "This is the heart of the house." For the first time, despite the thumps and bumps and craziness I'd just witnessed, the hair on my body stood on end.

The basement, like the third floor, has been the subject of the many urban legends and outlandish stories we would continue to find throughout our research. I was hesitant to go down into the basement and had told Krista only that there were many stories emanating from this space. At the base of the stairs, we found the hall to be very dark, with the only light coming from the "ballroom." But Krista had a very different take on that area. "This was not a ballroom at all," she said. "This was a meeting space." The room that holds most of the legends is a dark, narrow room with a dirty floor. As we peered into the space, Krista suddenly put her arm out in front of me, to keep me from walking forward. "We will respect you and this space," she said out loud. And with that she looked at me and said, "Go upstairs."

Standing once again on the main level in front of the mirror, Krista explained to me what had just happened. There were three dark spirits in that basement room, she said, and they had clearly had an effect on her. Even as she described her experience, rustling noises and the sound of light footsteps on the basement stairs were very evident to us both. At that point, she said something that would become my mantra each time I reentered the

house. According to Krista, who knows I am a particularly sensitive person, I was never to spend more than two hours at a time in the mansion, and I was not to go into the basement ever again. By that point, that advice was fine with me.

On that note, we decided to leave and walk over to the carriage house. Once again the spirit of the woman on the stairs made herself known to Krista and asked us to stay, or promise to return if we did have to leave. Krista assured her we would come back. The mansion's heavy front door has two locks, and I had been carrying the keys in my pocket during the walk-through. As we started to leave through the front door, I took the keys out of my pocket and in approximately three seconds they became completely intertwined in the metal spiral of my notebook. With frozen fingers, it took the two of us several minutes to free the keys. Once outside, we struggled with the door, which seemed to be jammed at the top and would not close. "She doesn't want us to leave," Krista said.

We struggled and fumbled and laughed at the absurdity of not being able to get a door to close. Finally, it closed and locked, so we thanked the house for allowing us to visit and walked down the steps. Snow had begun to fall, which was actually a welcome reprieve from the cold inside the mansion. It was warmer outside! Just as we turned to the west to walk the short distance to the carriage house, a huge pile of snow slid off the roof and landed right behind us. We both jumped. "She's trying to get our attention," Krista said. *We need to walk faster*, I thought.

The energy in the old carriage house was as different from the main house as day is from night. The former barn, which still exhibits evidence of the 1970s office renovations, seemed light, bright and open. Curiously, though, the spirit of an Irish housekeeper immediately made herself known to Krista and asked us why we were there. The spirit told Krista that the man in the main house was very dark and difficult and that if I ever needed to seek shelter during the writing of our book, I should come to her. The spirit also said something that I would carry with me throughout this endeavor: "Tell her to tell the whole story," she said. "It must be told."

In the days following our visit to the house, Krista spent hours listening to the digital recording. It took a week to work through it all, but when she finished, she called me immediately. "I don't want to scare you," she said. *Not a good start*, I thought. "But we picked up almost sixty comments on the recording, some of which are pretty disturbing. The odd thing is that I can't get it to erase off my recorder, no matter what I do. And the stupid thing doesn't always play. It's making me crazy."

The results were startling, to say the least. Krista was careful to filter out outside noise, so it's very evident what is coming from within the house and what is not. The range of voices and the different dialects heard are interesting to note. At one point, a male voice with an Irish accent is heard cheerfully singing. As Krista and I are attempting to secure the stubborn front door, a helpful voice can be heard to say: "I think it's jammed." And during the walk to the carriage house, a child's voice cries, "Mommy!" just as the snow slides off the roof. Once inside the carriage house, Krista had spent quite a bit of time describing to me her impressions, as we both found it to have such different energy from the main house. Following a comment of Krista's that the men in the carriage house seemed weak and unable to stand up to the owner, a woman's voice responds, "Not many could!"

Most disquieting are the comments that come immediately after Krista makes an observation. For example, in the "sad" room to the right of the main foyer area, we pick up a voice that says, "This [unintelligible] killed me." The voice of a woman pleading for help can be heard throughout many areas of the mansion. On the second level, where there is evidence of office spaces dating to the 1970s, Krista volunteered a remark about people in the offices having disturbing experiences. An elderly voice responds: "Enough!" A male voice in the tower room says, "There's nothing here," just as Krista walks in. But of all the recordings, one of the most chilling came as Krista said, "There's something about the mirror." A woman's voice responds, "It's *in* the mirror."

Overall, the experience with Krista was eye opening, to put it mildly. Of all my time spent there, the house was most active on that particular day. As we walked through the mansion, Krista felt compelled to cleanse it and tell the spirits they were free to go, and during my subsequent visits the house seemed friendlier and lighter to me. Krista also continually sensed the death of a child and a grieving mother, which she tied to the very early years of the house. However, without knowing any history of the house or the accompanying folklore, she had no way to put her impressions into context. Later, I shared with her what I had learned about the mansion's history, and only then did some of her observations begin to make sense to her, enabling us to make some connections to past residents.

When we were up on the third floor landing, still struggling to breathe, Krista had sensed the woman on the stairs and had remarked, "I'm seeing that her name began with an M, like Mary or Marie." Those names and others that start with the letter "M," which she could not quite see, developed into a common theme with Krista, one that was only reinforced when

Jordan and I began to compare notes. As a matter of fact, during further research, we would become obsessed with "M" names, to the point where we couldn't believe the coincidence (and the confusion) of so many women associated with the house having names that started with M: Mary Croke, Mary Patterson (who died in the house), Margaret Patterson, Martha Sudan, Mary Rae, Marion, Melodee—and we're sure there have been others.

Even though it was a crazy day at the mansion that first day, neither of us ever felt we were in harm's way. "The funny thing is that I don't once recall being in fear. Uncomfortable at times, yes," Krista said, "but with all its attempts to frighten us, we didn't react, so we thwarted a lot of the activity." From that point on, the house seemed to be free of much of its dark energy. At least, it seemed that way to me. However, that wouldn't always be the case for others who would visit the mansion with us later. The house wasn't giving up yet.

THE GOOD DOCTOR

As if to elude history itself, even the street address of the Croke-Patterson is cloaked in contradiction. The arched entry of the mansion confronts 11ᵗʰ Avenue, and yet records show that it was not until 1932 that the address was listed as something between 420 and 430 East 11ᵗʰ Avenue. Prior to that, the address was shown as 1075 Pennsylvania Street. As the house is technically built on three lots, the exact address is a little hard to pin down. The Denver Assessor's Office has it down as both 430 and 420, but most sources label it 420–28 East 11ᵗʰ Avenue. Although it would be simpler to keep referring to the location as lots one through three of Block 77 of Porter's Addition, the layperson probably has no idea how to plot that on a modern map of Denver. Suffice it to say that the mansion sits on the southwest corner of East 11ᵗʰ Avenue and Pennsylvania Street.

At the time the house was built, and on through the early 1930s, many city planners assumed that the residential development of the neighborhood would continue mainly north and south, along the non-numbered avenues such as Grant, Kansas and, of course, Pennsylvania. However, the architects of the Croke-Patterson Mansion must have insisted that the mansion be sited to face north, offering a commanding overview of the Capitol Building and the growing city of Denver in the broad valley below. During the 1930s, the massive arched entry was finally and officially recognized as the front of the edifice, and the house was renumbered accordingly. In fact, as if predicted by Thomas Croke himself, the change in address would mirror the residential growth along East 11ᵗʰ Avenue.

After Margaret and Richard Campbell sold the house in 1924 to the Louise Realty Company, the Croke-Patterson Mansion changed hands quite a few times. Over the years, the building would host a variety of different organizations, including the Joe Mann School of Orchestra, a radio station and various other public associations. In 1947, for the first time since the Campbells had moved away, the mansion would once again become a family residence. Dr. Archer Chester Sudan, relocating from his medical practice in Kremmling, Colorado, bought the mansion and used two of the apartments for his home and office. He rented out the other five apartments at the time, and his name was on the title. He and his wife, Tulleen, and their son, Archer Jr., occupied the house without making too much news of any kind until 1950. But before that subject is broached, a little background on the family.

Known as "Archie" in his boyhood days, Dr. Sudan was born in 1894 in Sioux Falls, South Dakota. Yet another historical enigma, this is the date that is most often cited, but he may actually have been born as early as 1890 or as late as 1896. His parents, Leopold and Catherine, were born and raised in Germany, and they married and began their family there before immigrating to the United States in 1888. Archer was the youngest of eight children, five of whom were boys. There are stories of his young life that include him attending to and healing small animals and farmyard creatures, finding within himself a penchant for medicine that grew with age. He moved to Chicago to live with one of his sisters and her husband for the duration of his high school and college careers.

Graduating from the University of Chicago with both bachelor's and master's degrees, and after completing Rush Medical College, he headed west to an internship at Denver General Hospital. He met and married a nurse there, Miss Tulleen Shepard, and together they returned to Chicago, where he would take a teaching position at the University of Chicago. In 1926, he found himself back in Colorado, on a fishing vacation in the mountain town of Kremmling. From there, the truth is a bit murky, but local folklore describes Sudan responding to a rural family's medical crisis and being inspired to set up a practice in the woefully unsupported wilderness of western Colorado. He sent for Tulleen, and she moved from Chicago to Kremmling to join him. He spent some twenty years in the mountains, building a small hospital and gaining national acclaim for his efforts toward helping Colorado's less fortunate and isolated rural residents.

Sudan eventually presided over the Colorado Medical Society and went on to win the American Medical Association's first gold medal "for exceptional service by a general practitioner" in January 1948. *Time* magazine published

an article on Sudan on January 19 of that year, going on to describe him as "big (6 ft., 245 lbs.)," and his hands as "ham like," which only added to his image as a larger-than-life character. Sudan certainly gave his all for the health of his patients, but after the hardships of over twenty years in the mountains, his own health started to fade. It was at that point, in 1947, that he decided to purchase the mansion on Capitol Hill and move his practice to a more urban environment. Little else can be found on Sudan's personal life, which is understandable—his professional career was more than interesting enough to paint a vibrant picture of his life. However, the few facts that are sprinkled throughout his biographies are more often than not misleading. And here, our story really begins.

Tulleen Florence Sudan, Dr. Sudan's first wife, moves like a wraith behind the text of her husband's medical accomplishments. Too often, she goes without mention entirely, and what little information can be discovered about her life is often undocumented or simply hearsay. Described by some as a "pretty little nurse from Kansas City," Tulleen was born in Missouri in or around 1894 (though her tombstone states 1902). According to census records, her parents, Hattie Florence Lykins and William Beck Shepard, were both born and raised in Missouri, where they established their own family and raised all seven of their children. The Shepard family appears to have relocated to Texas around 1920, and shortly thereafter, perhaps to find work as a nurse, Tulleen moved to Denver, Colorado.

Dr. Sudan and Tulleen's only child, Archer Jr., was born in 1927 in Grand County, Colorado. With a population of 567, Kremmling was remote and surrounded by mountains, and the nearest doctor, other than Sudan, was 57 miles away by a rough road over Rabbit Ears Pass, in Steamboat Springs. Denver was over 130 miles away. Daily life did not include indoor plumbing, let alone paved roads, and winters were especially hard. As the only doctor in a county of over 1,800 square miles, Sudan dedicated himself to his rural patients and thought nothing of driving or even walking miles in terrible weather to tend to them. Back in town, his wife saw to the patients in their tiny clinic in his absence, which often was for many days at a time.

As the wife of a country doctor in such a remote area, it couldn't be said that Tulleen had an easy life. Her husband's dedication was perhaps her loss, and it's not hard to imagine that she was often lonely. Nevertheless, she raised her son, and the family made their home in Kremmling for over two decades. By the time he turned his tiny clinic over to a young doctor named Ernest Ceriani, Sudan had left the population of Grand County far healthier than he had found it.

In 1947, the family made the move to Denver, and Dr Sudan set about building a new medical practice. He had found fame of sorts, having been the subject of several magazine articles, even traveling to Cleveland—by airplane—to receive the American Medical Association's gold medal. Back in Denver, he ran his practice out of the Croke-Patterson Mansion and found renters for the remaining apartments in the house. As dedicated as ever to his profession, Sudan continued to travel, serving on various medical boards and committees and at times even revisiting old patients in Grand County.

Life seemed to look up for Tulleen. She was in a more urban center, so it's likely that she had more opportunities for socializing and forming friendships among other ladies of her age and status. Her son had grown and left the nest, but she now had more activities and social engagements to keep her occupied than she would have had access to in a tiny mountain town. It might even be assumed that the grand mansion on Capitol Hill was a dream come true for a pretty little girl from Kansas, but with her husband still absent so often, perhaps Tulleen had only traded one kind of isolation for another. Of course, this is all speculation. For whatever reason, she abruptly came to grief in the winter of 1950.

On Sunday, February 5, Tulleen Sudan made the decision to end her own life. Whether she climbed the stairs to the second-floor bathroom or up yet another twisting staircase to the third floor is not recorded by history. She may have entered the tiny turret room and, locking the door behind her, gazed sadly out the small, curved window overlooking the front yard and the city beyond. We will most likely never know why or exactly where Tulleen chose to kill herself, but we do know how.

The death certificate released by the coroner's office states that Tulleen F. Sudan committed suicide via cyanogas poisoning, a method not often heard of. Cyanogas is created when black calcium cyanide crystals, a simple household pesticide used to kill rats and other vermin, are mixed with water. The mixture leaves behind a harmless byproduct—calcium hydroxide, a mild form of lime often used in food preparation—but when the gas is released, it kills anything in a reasonably airtight room within approximately three minutes. To paint a better historical picture of cyanogas, it has been compared to Zyklon-B, the pesticide used by the Nazis to gas prisoners at Auschwitz and Dachau. Some even go on to say that, as a tool of homicide, cyanogas is far superior to Zyklon-B due to its ease of use and simple, non-hazardous cleanup; the primary ingredients are also readily available to untrained consumers. Given these facts, it is quite plausible that Tulleen simply grabbed a box of rat poison on her way upstairs.

The exterior of the mansion in 1948, during the Sudan years. The iconic, four-story chimney appears to have been removed by this time. *Photo courtesy of Denver Public Library, Western History Collection, Orin A. Sealy, #X-26370.*

Her death was kept very quiet at the time, it seems. There is no obituary for her on file, at least not one that survives in accessible archives. Because of the stigma that suicide has long carried in society, it is safe to assume that Sudan simply wished the matter to be dealt with quickly and without public acknowledgement. Overcome with grief, he had Tulleen quietly interred in their double plot at Mount Olivet, her gravestone engraved with the simple epitaph: "Grant thy faithful servant a place of refreshment, light and peace." Perhaps most heartbreaking of all, she remains buried in that double plot alone.

There is very little factual information on Dr. Sudan from that sad time onward, until about 1955. In that year, Sudan married a friend and neighbor, Martha Hawkins, which presented us with an interesting piece of evidence: a release of inheritance tax lien. In fact, the only reason we are able to discuss factual details of Tulleen's suicide with any credibility in this chapter is due to a fortuitous accident involving the grantee/grantor records

for the Croke-Patterson Mansion and an odd note traced by a particularly observant employee in the Denver Clerk and Recorder's Office.

Our research into the Croke-Patterson's past owners led us to libraries and various city and county offices on a hunt for the title history. In the archives of the clerk and recorder's office in downtown Denver, an astute employee brought to our attention an odd pair of entries in the grantee/ grantor books: a "release of inheritance tax lien" and, just above that, the record of a death certificate. Neither of those two records, a lien or a death certificate, typically belong in the track books of deeds and titles, but for some reason they had been entered just above the documentation of Dr. and Martha Sudan, as well as an entry for Archer Jr., and the deed of the mansion. Since Tulleen's death was never publicized, it appears that Dr. Sudan may have had to prove that she was, in fact, deceased before he could marry Martha. A search for an owner had led to the discovery of a death.

With the discovery of the inheritance tax lien and, in particular, the death certificate, a new range of interesting questions was raised. Is Tulleen the woman who is at the root of the most persistent rumors about the house? Is she the apparition seen on the stairs and heard throughout the house? What drove her to suicide? And finally, why did Archer Sudan continue to inhabit the mansion until 1958 after such a personal tragedy?

These questions remain unresolved. Tulleen most definitely committed suicide in the house—that fact is very clearly recorded on the death certificate, along with her unusual method. However, she was forty-seven when she died, an age that makes the "lost infant story" highly unlikely. Her first and only child, Archer Jr., was already twenty-five years old. In the mid-twentieth century, when fertility studies and medicine in general weren't as advanced as they are today, it was even less common for a forty-seven-year-old woman to give birth than it would be today. Also, upon investigation at Mount Olivet Cemetery in Jefferson County, we confirmed that there is no one else buried with her in the Sudan plot. Had she lost a child, one would think that it would have been buried with her. Any interment in the other half of the plot, even if it was left unmarked, would have been entered in the cemetery records, and those records show no one to be there with her. We may never know why she killed herself, but we can be reasonably certain that Tulleen's suicide is unconnected to the rumors of the baby reportedly buried in the basement. That rumor can be laid to rest.

As to why Sudan remained in the house for eight years after his wife and the mother of his son ended her life there, that question, too, remains unanswered. It may have simply been a matter of convenience.

His medical practice was there. His life was there. His health was not the best. Nevertheless, three years after he and Martha married, they moved to Boulder County and left the mansion in the hands of the doctor's son, who was a physician himself. Dr. Sudan Jr. set up his office in the basement ballroom/billiard room and kept up the apartment rentals his father had begun in 1947. Very little is recorded about the house during this time, and even less documentation exists about Archer Jr. According to records in the Denver Assessor's Office, the Sudan family sold the house in October 1972. Shortly after this point, in April 1973, Mary and John C. Rae appear on record as the owners of the Croke-Patterson Mansion.

THE RUBBER ALLIGATOR

MARY RAE

It was in the early 1970s that Mary Rae got a call informing her that the Croke-Patterson Mansion was to be torn down to make way for a parking lot. The history major had already built a solid reputation as a preservationist of Denver's stately mansions, and she vowed to save the mansion from demolition. In fact, it was this very passion that led her to get her real estate license around this time, when you could count women real estate agents in Denver on one hand. Borrowing $5,000 from a friend, she gathered the remaining money needed and bought the place for approximately $50,000. Some seventy-nine years earlier, Senator Patterson had written a letter to his wife, Katherine, noting that the house was worth $40,000.

The fourteen-thousand-square-foot mansion was falling into disrepair, but Mary was bound and determined to save it. And she did. In fact, it was Mary's drive and persistence that earned the house a National Landmark designation in 1973. Mary never intended to live in the house, but she quickly realized the scale of the project she'd bought into. The cost to repair the deteriorating sandstone was estimated to be nearly $250,000. "It was like a bar of soap," she said. "The stone was just peeling away."

With the purchase of the mansion, Mary set about cleaning it up and doing some interior renovation. She personally stripped all of the woodwork

in what used to be the old dining room, the room immediately to the right of the entryway. "The house was intact at that time and it was beautiful. I had this grand idea to restore the entire thing myself." She was also faced with the grim task of cleaning up a storage area in the basement used by a doctor who had occupied the building, presumably Dr. Sudan's son, also a physician. She remembers when she first bought the house from the Sudan estate. "There were things in that basement that I don't even want to describe," she said. "It was awful, it was terrible."

She also became an instant landlord: at the time, the house was divided up into apartments. One was located on the main floor on the east side of the house; the others were scattered throughout the house.

I had tenants leaving in the middle of the night and not paying their rent. They heard babies crying on the third floor, and it was so unsettling and disruptive that they couldn't stay. Of course, we had no babies living in the building at the time. Other strange things happened to my tenants, and they were leaving at an alarming rate.

Most of the original mahogany woodwork still exists on the main floor. *Photo by Ann Alexander Leggett, January 2011.*

Mary began to research the house more deeply. She learned of its rich history and also found out about the many reports of hauntings. But there was one event that happened to the young couple in the first-floor apartment that she will never forget:

> *I remember it very well. At 4:00 p.m. on a Sunday afternoon I got a call from the husband. "You need to come over now!" he said. When I arrived, I couldn't believe what I saw. The apartment on the first floor, in what had originally been the library during the Patterson years, had a fireplace that had an enormous, heavy wood and brass insert. The insert had been pulled away from the fireplace into the room, as if it had been pushed from inside the fireplace. It would have taken super human strength to do this. Everything in the apartment was askew, and the wife was sobbing and the baby was hysterical. I will never forget it.*

The fireplace still exists in that room, sans insert. During our research, we found a photo of the fireplace with the old brass insert intact, in the 1963 book *Denver Dwellings and Descendants*. From our visits to the mansion, we had developed a mental map of all the rooms. Weeks later, while on one of our last walk-throughs, we realized that the once-shattered fireplace is on the wall directly behind the grand mirror in the front hall of the mansion—the very mirror that seems to arrest each visitor to the house and seems to be surrounded by a terrible chill. Krista was right: there is something "off" about that mirror.

Mary also described to us tales of a secret staircase located behind the bookcase in that first-floor apartment. Not long before our meeting with Mary Rae, Krista had voiced her belief that the house contained many secret passageways. Given the mansion's very steep roof, we do know that a narrow "dead space" exists between the interior walls of the third-floor rooms and the roof's structure. In fact, a distance of about twenty-five feet of that space is accessible via a small door-like opening in a corner closet of the southeast bedroom. Floor plans of the third floor imply an even longer passage running the entire length of the south side of the building and terminating in the infamous tower room. Whether these narrow spaces were intended or ever used as "secret passages" or are merely a byproduct of the roof design, we may never know.

In a crazy twist toward the very end of this project, our research assistant e-mailed us a familiar photograph of the mansion's exterior, but with a

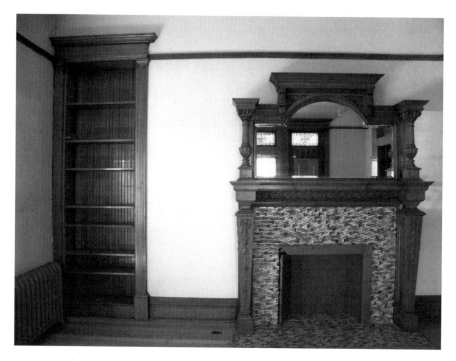

The library with the mysterious fireplace, which has been refurbished since the frightening "event" in the 1970s. *Photo by Ann Alexander Leggett, April 2011.*

formerly unnoticed dormer window circled and the caption, "Where is this room, and how do you get up there?" Hiding in plain sight, that fourth-floor dormer window does not correspond to any floor plan, mental or otherwise, that we have of the Croke-Patterson Mansion. We still don't have an answer to that question.

After the fireplace event, Mary decided to hold a séance in the house. "I was pretty lighthearted about it. I thought I'd have wine and cheese and invite a few friends over. Well, it quickly became apparent that we were dealing with more than we had bargained for." According to Mary, the medium did in fact summon spirits, and at one point one of the men in attendance started to bark like a dog. Mary shared very few of the events of that night with us. Obviously, it was an extremely unsettling experience for her.

"After all that had happened, combined with losing tenants and not having the money for the upkeep, I knew I couldn't keep the place," she said. Knowing that she had at least saved it from demolition, Mary sold

Mary Rae at the Croke-Patterson Mansion, April 2011. *Photo by Ann Alexander Leggett, April 2011.*

it to Trenton Parker, who began to remodel the house into contemporary office space. During our discussions with Mary, she confirmed one horrific fact that had, up until that point, seemed like just another piece of mansion folklore. "The dogs jumping through the window really did happen during the office remodel. That is a fact. I saw the evidence."

As a champion of Capitol Hill's historic mansions and a longtime, well-respected Realtor, Mary has been involved with many historic properties. "I got caught up in saving these old homes," she said. "It became my passion. But nothing has ever gotten to me like this place. I know it's haunted, and it is a dark energy there combined with sadness. When I tell people it is haunted, they look at me like I'm daft."

Mary had not visited the house in some time but agreed, somewhat hesitantly, to accompany us one time while we did research for this book. She was wistful during that visit and visibly upset at how the mansion had gone downhill since its glory days. Clearly, she still had fond memories of the house, and it was a pleasure to walk with her through the main-floor rooms of the mansion and hear her describe what the original interior once looked like. If not for Mary Rae's efforts, the Croke-Patterson Mansion would now be the site of a parking lot, and we would have lost far more than a grand old house.

MARION

Moving into the Croke-Patterson Mansion in the early 1970s was a treat for Marion, who was employed as a Channel 7 news reporter during her stay at the Croke. She and her roommate, a female Denver police detective, had moved up from a much smaller place and found the old mansion fascinating. Their apartment was on the second floor, on the east side of the mansion.

Marion's odd experiences in the mansion really all started with a rubber alligator. Since the women had moved out of a furnished apartment and were lacking in funds, the maintenance guy at the Croke-Patterson kindly told them to help themselves to whatever furnishings they could find in the unused areas of the mansion. Marion found an old brass bed in the basement, and with a little work, it became a charming addition to her room in the new apartment. While out shopping for items to decorate her room, she'd found a rubber alligator with a silk ribbon leash, perhaps once a gift

from a sightseeing trip. Thinking it would be a whimsical addition to the apartment, she put the alligator on top of the beautiful antique dressing table she had found in the carriage house.

The alligator sat atop the mirrors of her dressing table—until one day it up and disappeared. It was odd that it would be moved anywhere, particularly since Marion's roommate was not the kind of person to play practical jokes. And they had made sure that their apartment was secure, making it highly unlikely that someone could break in—and certainly not to steal a toy alligator. Mysteriously, it reappeared in the kitchen. The toy was returned to its place atop the mirrors, only to disappear again. It resurfaced in one of the window nooks and then was gone again. It next turned up in the bathroom—and on and on it went. It became a perpetual game of alligator hide-and-seek. The roommates never could explain it.

The women began to feel a presence in the house, and they found themselves able to relate to the spirit. They felt it was comforting to have the presence surround them; it seemed protective. Not everyone shared their acceptance of the spirit, however. One night, after hailing a cab to return to her home, Marion jumped into the backseat and gave her address to the driver. "You live there?" the man asked. "How are you handling that? I used to live there in the '60s, but my old lady made us move out. She couldn't handle the baby crying. And we didn't have a baby, and there was no baby in the building."

But Marion loved the mansion, and she came to feel that the female presence watched over her and her roommate. "Thirty-eight years later, I still absolutely believe that I had a very good relationship with a female spirit in that building. I never saw her, and I never heard her. But she cared for us in her house. I was very happy there in spite of some creepy things." Marion thinks it may have been serendipitous that she found those two pieces of furniture in the mansion, and she wonders if perhaps she had a connection to the woman because of that. That being said, the spirit clearly did not feel that the top of her dresser was any place for a rubber alligator.

After living in the mansion for about a year, Marion went to law school in Washington, D.C. She later returned to Denver, where she continues to practice law.

Peter Boyles

As a Denver radio celebrity for thirty-five years, Peter Boyles has hosted his fair share of interesting broadcasts. But the events he's held at the Croke-Patterson Mansion are among his favorites. "I've done several shows there. We keep coming back. In fact, it's the only place we've ever returned to." Twenty-five years ago, Peter started doing Halloween broadcasts, and based on its rich history and reported hauntings, the Croke-Patterson Mansion was the perfect locale. The broadcasts feature local historians, paranormal investigation groups, previous residents and calls from people with paranormal experiences. In fact, Mary Rae has been a guest on his show.

Recently, Peter has set up the event as an opportunity to spend the night in the mansion for a fee that benefits his favorite charities. "We had approximately fifty people there for our broadcast last year. It's a fun event. The Croke is the epicenter of Denver in terms of haunted places." While he has never had anything unusual happen to him personally on these visits—and he has spent the night there three times—others have. "A policeman friend of mine came up from the basement one year and asked who the old guy was on the couch. There was no one else in the basement while he was down there."

Peter's take on the house mirrors the reactions of almost every other visitor who has spent any substantial amount of time there: "There's definitely something going on there. You can't count it, you can't weigh it and you can't measure it. But too many people have had experiences to say anything to the contrary."

A Scientific Approach

It's an understatement to say that the world of paranormal investigation is pretty bizarre. Without a doubt, working with these enthusiasts was an eye-opening adventure. Throughout the writing of this book, we went from experiencing the psychic realm to recording firsthand accounts of hauntings to accompanying two separate paranormal investigation teams in the mansion. But it was the paranormal investigation work that perhaps fascinated us the most. The groups were completely different, from their methodology and belief systems to their interesting and colorful personalities. Most members of these teams have day jobs and ghost hunt by night (or by day, if the situation calls for it). Their processes are well choreographed and precise. We had no idea. All we did was provide the house and then sit back and watch.

Paranormal investigation work is big business. On any given night on television, you can find a ghost-hunting show. Some are over the top and theatrical, while others seem fairly scientific. Sitting in your living room, you can't help but wonder how much is "real" and how much is made-for-TV. Coming into this project, television ghost-hunting shows were our only previous experience in this field; we had a lot to learn.

Not only were we working with the paranormal teams during our research, but we were also dealing with psychics, and we found the two don't always mix. Each psychic, clairvoyant, empath and sensitive has his or her own distinct talents, obviously, but generally they pick up on sounds, feelings, emotions, images, communications and many types of energy in the spaces

around them. Instead of using scientific equipment, they use their senses. They are tuned in, to a higher degree, than most of us. Some paranormal researchers discount the contribution of psychics to spirit investigations, while others welcome the input. Krista Socash maintains that her psychic ability has always been a part of her life, as has her connection to the spirit world. "I have never known a time in my life when I ever questioned that ghosts and spirits existed," she told us. "I respect those who are skeptics. It is not about converting those who are skeptical or trying to prove anything. However, I have come to realize that there is no proof like firsthand experience. I have worked with so many people who believed that things like this didn't exist until they experienced something paranormal."

The scientific take on the paranormal is far different from the sensory perceptions used by psychics. And yet, as Krista would remind us, science will only support things so far. "For example," she said, "love cannot be proven by science, but science can prove the reactions to love and its symptoms and effects on the body, etc. Our bodies are the supreme scientific instrument to sense things and gather information, but we have to be tuned into ourselves, our feelings and feminine sides and such."

There is no doubt in our minds that psychics and clairvoyants have the ability to sense what is going on in a particular place or with a particular person. They all have different abilities: some see apparitions, some hear voices and some just have "feelings." And at times, they can be eerily accurate. We heard these people describe occurrences in the mansion about which they had no prior knowledge—occurrences that we knew to have happened. Their descriptions closely paralleled or even confirmed what other people had told us about their own firsthand experiences. That's when our hair really stood on end. These people were intuitive and sensitive to the feelings that we had about the house ourselves; their observations made sense to us. They made the spirits in the house seem very personal and interconnected to the history.

According to Bryan Bonner, however, using science (rather than psychics) is really the best way to investigate haunting claims. Bryan is a founder of the Rocky Mountain Paranormal Research Society, the first of two teams we had in the mansion. He considers his team to be "paranormal claims investigators" rather than ghost hunters, remarking that there are many enthusiasts who risk discrediting the paranormal community by "turning it into an overblown Camera and Social Club." Bryan asserts that most of the purported haunting cases investigated by the Rocky Mountain Paranormal team can be explained in one way or another using scientific methods.

Bryan Bonner (left) and Matthew Baxter of Rocky Mountain Paranormal monitor audio and video feeds on their computers during their most recent investigation in the mansion. *Photo by Ann Alexander Leggett, February 2011.*

However, he does admit that science can't *always* explain some of the strange phenomena they have encountered since the group was formed in 1999.

The team's approach is pretty straightforward. "We enter the house as skeptics, in the true sense of the word," Bryan said. "We're not looking for ghosts, and we're also not looking to debunk anything. We are just looking for the truth. We are here to examine the claims." A methodical, analytical process quite often results in a more mundane explanation being offered for reported paranormal phenomena. In his final notes on the Croke-Patterson investigation, Bryan wrote:

> *Throughout the investigation we noticed that there are several different places in the mansion that have a draft from outside. This is caused by the old windows in the mansion not having a good weather seal as well as several windows being broken in several different rooms. One of the most noticeable of the drafts was at the bottom of the main staircase. This one was so strong that there was a noticeable breeze at the base of the main stairs.*

In sharp contrast to the view of the psychic community, Rocky Mountain Paranormal believes that personal experiences are not at all reliable when investigating paranormal activity. According to Bryan, the human body makes a horrible recording device. "Medical issues, sleep deprivation, you name it, they all can cause people to see and hear things that can be described as paranormal." When visiting a purportedly haunted environment, a person's immediate surroundings can combine with his own predispositions to convince him that he has witnessed paranormal activity. The rooms of an old house might have unusual proportions—even slightly tilted floors or walls—that subconsciously create unease. Add a few ghost stories and even ordinary shadows begin to look sinister.

The Rocky Mountain Paranormal Research Society is contacted on a daily basis by people seeking help in determining the cause of seemingly paranormal activity in their businesses and homes. As a result, Bryan and his research associate, Matthew Baxter, have encountered claims of everything from hauntings and levitations to alien abductions and telephones that talk to the dead. They have investigated many haunted locations throughout the country, but there is just something about the Croke-Patterson that keeps them coming back.

Our experience with the paranormal groups was both enlightening and entertaining. Unlike the psychics who came into the house and quietly took it all in, making comments along the way—some unsettling, some obvious—the paranormal teams make quite the opposite sort of entrance. They arrive like gangbusters with vanloads of equipment. They have measurements of all of the rooms, taken prior to the nights of the investigations, so that they can come armed with the correct scientific equipment. There was so much hustle and bustle in the house upon their arrival that our immediate thought was: *if we were spirits living here, we'd be long gone.* The scene is frenetic. These people don't waste time. After all, they have to set up cameras, sensors and computers and then be ready for an overnight stay. While some of the team unfold tables and run extension cords, others lay out sleeping bags and run out for food. A circus-like atmosphere pervades the mansion, but after all of the rigging, wiring and equipment testing, everyone settles down, and the serious work begins. And these folks are truly serious about their work.

Rocky Mountain Paranormal was the first of two paranormal investigation groups we had in the mansion. No strangers to the house, they had been there on several other occasions, doing investigations and as guests of radio shows doing remote broadcasts from the location. Bryan

and Baxter are also no strangers to the unique history of the Croke-Patterson Mansion. They have interviewed past owners and residents of the mansion, and their knowledge of this history, and of so much of the crazy folklore surrounding the house, has made them very respectful of the property. "We have tried to help the public understand that there are just as many urban legends about the mansion as there are true stories," Bryan said. As a result, we found that despite the initial pandemonium, their investigation had a certain reverence about it.

Their investigative approach was different than you might expect, and it certainly wasn't similar to what we had seen on TV. The team arrived early in the evening on a Friday, along with Jack Hanley, folklorist with the University of Colorado at Boulder and creator of *Colorado X: Casefiles of the Paranormal*. There was a video crew present, filming for a television series currently in production (to be hosted jointly by Jack and the Rocky Mountain Paranormal Research Society) called *Chronicles of the Unexplained*. With a photography crew also on hand to document the event, the place was overflowing with people. Once the publicity photos were taken, the interviews completed and the necessary film footage shot, the research team set up for its overnight investigation.

The equipment included nine cameras, including infrared video and still cameras, infrared lighting and two studio microphones (one in the basement and one on the third floor). The video cameras were placed where there have been reports of apparitions or other spirit activity and set up to record continuously. Remote thermometers and various other sensing devices were placed throughout the house, including electromagnetic field detectors and a seismometer. Folding tables held an impressive array of laptops, monitoring systems, video processors and soundboards.

Interestingly, the investigators did not use any conventional motion detectors. According to Bryan, the high numbers of false positives generated by motion-activated devices all but negate their usefulness. An infrared motion sensor can even be triggered by the focus beam of a digital camera and in turn may affect the camera's image. They also don't use EVP (electronic voice phenomenon) monitors, as they feel the devices are counterproductive. "We don't use them because that's conceding up front that there's something there. You've already compromised the investigation."

Nothing seems to play tricks on us more than our own preconceptions. There seems to be some truth to the saying, "You see what you want to see." Tales of spirits in the Croke-Patterson Mansion are pervasive enough that investigators are challenged to separate fact from fantasy. "One of the

consistently reported paranormal events was that of a 'ghost' being seen walking up the main staircase," reads another segment of the final report from Rocky Mountain Paranormal.

> *This was discovered to be an optical illusion. There is a chandelier that hangs in the middle of the main entrance room that has a large ball on the bottom of it. When a person is walking from the east side of the mansion into the main entrance room, in just the right conditions (low light or with a night-shot camera), the ball on the bottom of the chandelier can be mistaken for the shape of a person ascending the stairs.*

The team also has equipment to record both natural and man-made EMF (electromagnetic field) measurements. Paranormal activity is often linked to energy fields, and a high reading on an EMF meter might indicate the presence of a ghostly entity. However, electromagnetic fields exist throughout the natural world: the earth's magnetic field, solar radiation, lightning. Any living being produces an electromagnetic field. People are exposed to man-made EMFs in everyday life, in everything from power lines to computers to cellphones. Even the wiring in the walls of a building produces a measurable field. Electromagnetic pollution has been implicated in a wide range of health problems, though not without controversy. EMF meters were originally designed to register an overall level of exposure, and as such, a single meter can't definitively locate the source of unusual electromagnetic activity. By using multiple meters, however, the source of an anomaly may be triangulated. This allows the investigative team to establish a baseline level of activity for the house and confirm or rule out some of the more mundane causes.

Around the clock throughout the night, members of the team monitored all of the audio and video feeds on computer screens, recording all the measurements and readings to compile into a final report. Occasionally, they would fast forward and then scan backward on their computers to watch for subtle changes. Everyone on the Rocky Mountain Paranormal investigative crew is well trained in the use of the equipment. That's a must, according to Bryan. "If you aren't well trained, you'll find ghosts all the time. Most groups tend to view their equipment as 'ghost detectors.' There are no such things." In fact, much of the gadgetry touted in the paranormal community is counterproductive when in overly enthusiastic but untrained hands. Bryan walked us through all of the devices his group would be using, and we found it fascinating to see how they all worked. Looking at the team's extensive

setup, we began to appreciate the astonishing amount of data that would be collected and analyzed. All of it was new to us.

In contrast to many ghost investigation shows you might see on TV, which tend to favor a theatrical "lights-out method," Bryan and Baxter prefer to conduct their investigations with normal lighting. The thinking behind this is that people typically report seeing apparitions during their normal routines, not in total darkness. There's also some scientific jargon that goes along with the lights-on versus lights-off theories, but for the most part it involves lens flare and other orb artifacts in photography. This is another way of saying "light distorted within the camera lens" and "capturing otherwise invisible particulates in the air." Many amateur ghost hunters have excitedly reported the presence of ghostly "orbs" in photographic images, not realizing that the spots are simply backscattered light from the camera flash reflecting off airborne dust. Bryan pointed out that with the proliferation of inexpensive digital cameras, paranormal websites are rife with snapshots of purported ghosts. Recently popular are photos of "vortices," which usually turn out to be nothing more than wrist straps in front of the lens.

Another benefit of the lights-on method may be the elimination of distracting and misleading shadows, particularly in an urban environment. "Other claims of ghostly phenomena are of seeing people walking in different rooms when there is nobody in the mansion," Bryan reports. "This is easily reproducible by watching the reflections and shadows caused by traffic on the two streets that the mansion is located on. This effect is accentuated due to imperfections in some of the glass in the windows. This glass is not optically clear any longer due to its age and the pouring effect of the glass over the years."

Suffice it to say, when we left the Rocky Mountain Paranormal crew for the night, they were settled in front of their computer monitors in the well-lit main entryway, and the house was quiet. And it would remain quiet throughout the night and the next day. Altogether, the team spent over thirty hours in the mansion. According to Bryan, the mansion was very "calm" throughout their investigation, and their final report listed no signs of spirit activity. In fact, during each of the five sessions the group has spent in the house over the past three years, they have always found the Croke-Patterson Mansion to be very peaceful. "It's a great old house," Bryan said. "I'd love to live there."

GHOSTLY ENCOUNTERS

KATE

She approached slowly, taking the formidable stairs one step at a time. Upon reaching the top of the worn steps, she looked straight up and took in every piece of the house, shifting her gaze from left to right. Seemingly finished with her visual assessment, she closed her eyes and stood still for a moment. Then her eyes opened, and she seemed to brace herself for the words that would fall from her determined lips. "I'm back, you son of a bitch. You win. What do you want from me?"

This was my first meeting with Kate, but it obviously was not her first visit to the mansion. She had come to the Croke-Patterson Mansion this time at the request of Kevin Samprón, owner of Spirit Paranormal Investigators, and it was clear that she was intensely nervous about being back. After hearing the details of her history with the house, her anxiety was understandable.

In October 1993, Kate and her mother had visited the mansion on a haunted house tour of Denver. During that first visit, every room brought a different feeling, some mild and calming, some terrifying. Kate vividly remembers walking down the stairs to the basement and suddenly feeling physically ill. Up on the third floor, as people on the tour stooped to enter the infamous tower room, Kate stepped back, feeling dizzy. Negative energies seemed to swirl around and close in on her. She was overwhelmed. The dark

energy she sensed in the house haunted her, and the discomfort of that visit would stay with her for years.

Kate considers herself to be a sensitive, or an empath, meaning she is deeply perceptive of emotions and psychic energies. Sensitives are spiritually attuned and often experience the emotional state of another person as if it is their own. To varying degrees, they may even have the ability to sense emotional energy across time, picking up on occurrences from the past. This ability, according to Kate, is both a blessing and a curse. In the case of her time in the Croke-Patterson, it was the latter.

The ways that Kate would become so connected to the Croke-Patterson Mansion are strange enough, even without her empathic nature. After her initial visit on the haunted house tour, she couldn't get the house out of her mind. She replayed the experience over and over again. The energies took root and wouldn't leave her thoughts. She says her first take on the house was that it held a very dark energy and was full of sadness. She couldn't figure out why the house would affect her so. A series of coincidences, if we can call them that, would lead to her next visit to the mansion.

A few months after that October night, Kate enrolled at Denver's Art Institute. She was trying to find a nearby place to live when she happened on an apartment online that caught her fancy. There was a long waiting list, and yet for some reason she felt she had to live there; she signed up and prepared to wait. Eventually, a unit opened up, and she signed a lease. It was not until after she moved in that she realized that she was only two blocks from the Croke-Patterson Mansion. How had she not known? What were the odds that she would find an apartment in Capitol Hill, so close to the very place that would not leave her thoughts? She found herself avoiding driving or walking by the place. She would catch a glimpse of one of the dark turrets while driving up the street, and she would shudder. But this was only the beginning.

In the mid-2000s, Kate went out on a date with a man she met through an online dating site. "We went out and had a nice dinner," Kate says. "And we got to talking about where we lived. When I told him about my apartment, he said, 'Oh, really? I just live a few doors down. You know the Croke-Patterson Mansion? That's where I live.' Needless to say, I was shocked. Our relationship didn't continue much beyond that point." She couldn't believe the coincidence.

Kate says she has always been into ghost hunting, mainly to try to find the root of why she is so sensitive to energies in homes that are supposedly haunted. Eventually, she got in contact with Kevin at Spirit Paranormal

Investigations and asked if she could become a part of his team. She still remembers the phone call she had with him. "I'm up for investigating any place," she said, "except I don't think I can ever go back into the Croke." It was agreed, and she was part of the team.

She'd been with the Spirit team for less than a month, and in the field for only one investigation, when she got the call. "Kate, you are never going to believe this," Kevin said. "An author just called me. She is writing a book on the Croke-Patterson, and she wants us to do an investigation." Once again, the coincidences seemed too close for comfort.

According to Kate, it took a tremendous amount of courage just to step foot into the house again. But she says she felt compelled to go. "It has made me physically ill and has haunted me so badly for nearly twenty years, yet I felt like it wanted me to come back. It was trying to draw me in. I wasn't sure if I was supposed to help it or what. I was either *supposed* to go or *never* go back."

Coming full circle, there she was at the front door again, issuing her personal challenge to the house. The team members were conducting a pre-investigation walk-through, hurrying around figuring out where to set up their cameras. It was interesting to observe Kate as she walked from room to room. She was in her own world, and at times she turned her head as if to listen to things the rest of us could not hear. She was calm and reserved but also seemed to be on the verge of tears.

After so many years, it was the third floor that still held the most emotion for her. She admitted that she'd had nightmares about the "nursery" room with the little tower room attached. Her dreams were of a young girl crying and pounding on the door. With some urging, she agreed to enter the tower room and sat on the floor trying to keep her emotions in check. "I feel a woman or a child is here," she said. "She is in tremendous pain. I feel she may have died here mourning the loss of a child."

With the visit over, we stood in the front yard, and she expressed her relief at being able to face her fears. She gazed up at the house once again, and a small smile came over her face. "I did it," she said. Her relief was painfully short-lived. The phone call that came to us two days later was shocking, to say the least. Upon returning home from the mansion, Kate had found her beloved seven-year-old collie dead in the backyard. Understandably, she was devastated. "Was it the house?" she asked us. "I shouldn't have gone back. It has taken something from me that I love."

This terrible event notwithstanding, Kate was faced with the difficult decision to go back to the mansion one more time, as the actual paranormal

investigation was to take place three days later with the Spirit Paranormal Investigations team. Her mother, also a sensitive, pleaded with her to stay away. But she did return for the investigation, for just a few hours, leading the team through what she felt were areas where energies were strong. Kate said that for the most part, she'd been able to convince herself that her dog's death was a horrible coincidence and that neither the house nor the spirits in it were "punishing" her. On her return to the mansion, she tried to replace her antagonistic attitude with a more compassionate tone.

She would face even more strange events that night. She had the same overwhelming feeling of fear and sadness that she had experienced on her previous visits, but this time she also sensed an evil presence in the basement, a space that had not bothered her previously. All in all, it was a rather uneventful night, and she was relieved to finally be leaving the mansion at the end of her shift. After she said goodbye to the investigation team and started to leave, however, she felt something or someone suddenly grab her arm. When she arrived home, the babysitter reported that strange electrical interferences had occurred in Kate's house, and Kate found the family's pet fish floating dead in its bowl. Another coincidence? Even more disturbing were the four red marks on Kate's arm that looked like fingerprints. A doctor could not make a conclusive diagnosis, and yet the marks remained for five days.

Kate says she will never go back to the Croke-Patterson Mansion.

LEIGH

Kate's mother, Leigh, accompanied her to the investigation partly to witness the event but mostly to watch over her daughter. During their tour of the mansion in 1993, Leigh had felt a sense of being unwelcome in the mansion from the minute she entered. "There was a pain that speared through my heart, and I immediately felt that the inhabitants had experienced unbelievable agony and desolation, the likes of which most of us could only imagine," she said.

> *As we went up the grand staircase I was certain I should turn around and leave immediately, but not wanting to scare the others I followed until we reached the small tower room. I couldn't move as waves of nausea and fright held me almost incapacitated. I had to leave the house and I*

was horribly ill. Several of my friends on the tour felt the same things and they left as well. Over the next few days, nightmares, depression and uncontrollable crying plagued me. It took three weeks for things to get back to normal.

Leigh continued to be concerned for Kate, whom she could see was connected to the house. She felt the mansion was definitely trying to lure Kate back, and she vowed to not let her return without being there to watch over her. Both Leigh and Kate had found places that were impossible to walk through, as if invisible walls were making hallways impassable to them. The sensation of being unable to breathe hindered them both, and Leigh felt physically and mentally unable to remain in the house. "It felt as though the whole place was weeping," she said. "It felt black and hopeless."

Leigh believes the Croke-Patterson Mansion holds many mysteries. "This is one of those places that have a horrible form of darkness or evil that is best left alone. There are places that have secrets that are not worth unlocking, and I truly believe this house to be one of those."

Dan

It started out as an assignment for Dan: learn about paranormal research in preparation for a potential acting role in a movie about ghost hunting. The Croke-Patterson Mansion was the perfect location. Dan came into the Croke as a skeptic, a total non-believer. That would not be the way he left.

Interested in doing some live research on the subject, Dan contacted Kevin Samprón, owner of Spirit Paranormal Investigations, and the next thing he knew he was in the mansion on a ghost hunt. A man of a large stature, Dan doesn't seem the type to be easily frightened, and clearly he wasn't when he entered the house for the first time. On the contrary, he was actually trying to get something to happen—*anything*. "I was trying to make it mad," he recalled. "I was sitting on the main staircase by myself, as others were setting up upstairs, and I was yelling 'C'mon, let me hear from you!'" With that challenge, Dan proceeded to bang on the stairs two times, only to be met with two matching thumps coming from the empty basement. He pounded again, this time three times in succession. Three thumps came from the dark basement below. He then looked up at the infamous mirror, only to see the images in its reflection warp and twist before his eyes.

Standing in the main level of the mansion, Dan describes his unnerving experiences in the house. *Photo courtesy of Jane Carpenter, March 2011.*

His experiences that night grew in intensity. He and a cameraman looked out toward the front door at one point and saw a head in the lower corner of the sidelight, just inches above the ground. They also saw a head with indistinguishable features in the main stained-glass window that rises above the front entry room. But the most terrifying event of the night happened on the stairs, where so much of the spirit activity seems to be centered.

"There was a reporter in the house and one of the owners of the mansion as well," Dan told us.

> *The owner and I were sitting on the bottom of the main staircase, and the reporter was standing at the top of the basement stairs when all of a sudden a huge dark cloud moved in front of her and actually covered her legs. Her legs just disappeared from view. We screamed, and she ran back over and sat on the stairs next to us. I then looked up to see a huge head and shoulders, rising above us to our left, leaning over the stairway railing toward us. I couldn't make out any features.*

The event—or their reaction to it anyway—was caught on tape by one of the investigation cameras set up to catch activity on the stairs. Though the right-hand portion of the staircase where the apparition appeared is not in the frame, Dan can be seen looking up and yelling in response to the sight of the head coming down upon them, as the two women scramble to get off the stairs.

According to Dan, the Croke-Patterson is indeed haunted. "I may not have believed it at first, but I do now. There are lots of spirits here, but there is one in particular that's in charge. There's no question about it." He feels the apparition on the stairway that chose to frighten them that night may in fact be that dominant spirit. "It was very angry with me. I think if you came in here and provoked the spirits, you would get results. I sat on those stairs and basically said, 'Come on, be a man! Show yourself!' Well, it did."

MELODEE

Over her seven-year stay in the house, the paranormal experiences that Melodee had were too numerous to count. In talking with us, she would often say, "Oh *that* happened so many times, countless times." Basically, she learned to live with the spirits and felt that the majority of her encounters were peaceful. Peaceful, but unnerving at times. Melodee and her veterinarian husband owned the mansion from 1998 to 2005. Strange occurrences started almost from day one. Her husband did not believe the mansion was haunted, but Melodee knew otherwise.

Probably the most common haunting was by the young woman who would float down the main stairway and disappear through the sliding wood doors off the left side of the main entryway. Eerily similar to Krista's observation, Melodee recalled, "She looked to be about eighteen or nineteen years old, and she always wore a white apron and a nightcap of sorts. She seemed meek and sickly. She never said anything; she floated by on that same path, time and time again." Throughout our interviews, we would often hear about the apparition of a woman on the stairway. Accounts of her appearance varied, but most agreed that the woman seemed very ill.

Melodee's husband kept cats in the "cat room" on the third floor, a room that to this day seems to make most people extremely uneasy. According to Melodee, the room on occasion also made the cats uneasy. "One night we heard the cats start to shriek and howl. When I opened the door, they were

The oddly shaped "cat room" on the third floor has had many strange occurrences happen within its walls. *Photo by Ann Alexander Leggett, January 2011.*

literally climbing the walls." Her husband's office on the third floor always seemed to be teeming with paranormal activity. "He kept his desk drawers locked," Melodee said. "But there was a couch in the room, and we would sit and watch the drawers open and close by themselves, over and over. If you got up and tried to open the drawers, you would find them to be locked. We would also watch the doorknob turn on the small closet door in the same room." During our own visits to the mansion, we had found the opening within that closet and access to what may have been a narrow passageway beneath the steep roof of the mansion. Of that closet, Melodee said, "This was the door that we always had trouble opening."

Probably the most profound event occurred when Melodee was in the later stages of her pregnancy with triplets. "I was in bed and was very uncomfortable, and it was difficult to roll over. I looked up to see the apparition of a woman. We actually spoke to each other without words. She told me her name was Kate, and with that she held out her hand to help me. It took it, and it felt as solid as anything else around me. I was able to sit up and turn over, and she dissipated. It was a very loving exchange." Could this have been the spirit of Thomas Patterson's wife, Katherine?

Melodee's triplets were keen observers of the spirits in the house, and even though the basement was a playroom, they disliked one particular corner. "They didn't like sitting in the 'reading corner' in the northeast corner of the main basement room," Melodee recalled. "They said there was a man there who always stared at them. I never had a good feeling about being in that corner either. I always got the creeps, but it made sense once they told me about him." Even though Melodee's children were too young to talk about it at first, they would stare quite a bit at that one spot and cry. "Once they were able to verbalize what was occurring, they told me he was very tall, very thin and dressed in a top hat and old gray-black colored clothing," Melodee said. "A vest, spats, coat—the full formal thing of an era gone."

Upon moving into the mansion, Melodee began to hear more of the folklore associated with it. "I heard about the baby buried in the basement in the ashes of the coal furnace. I even sent the ashes out for extensive testing, but there were no human remains found. I can't tell you why, but I believe that event never occurred. I just get that impression every time it comes up in a conversation." But there are other tales she cannot bring herself to dismiss.

Just as the grand mirror in the Croke-Patterson Mansion seems to hold deep secrets, the fireplaces, too, have their mysteries. According to Melodee, during the 1970s, when the mansion was home to several offices, the tenants were having so many problems that they called in a priest to bless the

Over the years, the basement has been home to a meeting space, a billiard room, a medical paraphernalia storage area and a children's playroom—and plenty of paranormal activity. *Photo courtesy of Jane Carpenter, March 2011.*

home. Office machines turning on and off by themselves and other strange occurrences made the tenants uneasy. The front parlor once had a grand fireplace—the very one indicated by the once-towering chimney on the front of the mansion—and it was to this room, apparently, that the priest was summoned. A neighbor and friend of Melodee was in attendance, and Melodee recalled her story:

> *The priest came into the front parlor on the main floor, and as he began the blessing, the walls began to crack. As plaster fell to the floor, a fireplace that had been sealed over became visible, and gray-black smoke poured out into the room. A vortex of wind whipped around the priest and as things flew about, they heard a hateful male voice scream, "Get out!"" My friend refused to set foot in the house from that point on, and apparently all those in attendance made a pact to never speak of it for fear of conjuring up that sort of evil again.*

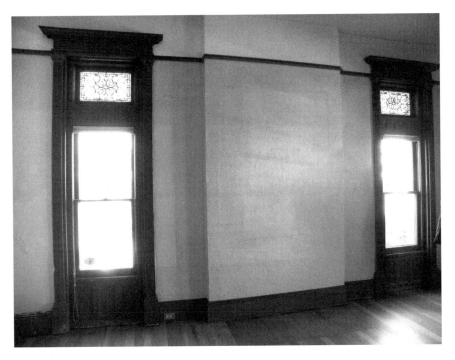

The front parlor, reportedly the scene of an attempted exorcism, today shows the blank wall and floor patch where the mysterious fireplace used to be located. *Photo by Ann Alexander Leggett, April 2011.*

Not too long before this, Mary Rae and her tenants were known to have had a similarly terrifying experience—though no priest was involved—with the fireplace in the apartment adjacent to that front parlor. As with so many occurrences in the Croke-Patterson Mansion, some dates and details remain elusive. Was there a demonic spirit in the mansion, bursting out of two fireplaces in the space of ten years? Or did an eighty-year-old chimney simply collapse, filling a family's apartment with soot and debris?

Melodee attended the pre-investigation walk-through we had with the Spirit Paranormal group, but on that day she found the house to be very calm and very different from when she lived there. "I worked very hard to produce as much love and light in the places I lived, and I never had any negative experiences in all the years I lived there."

VALERIE

The research that went into this book led to meeting new friends in all walks of the paranormal and historical community. We also discovered, sometimes unexpectedly, new common interests with old friends. While Jordan was burying herself in research and writing, I invited my friend Valerie for some on-site investigations of my own. We laugh about it now—how I managed to get Valerie involved with the Croke-Patterson Mansion—but there is still an underlying respect for the house that pervades our humor.

A business colleague who had grown into a fast friend, it turned out that Valerie has experience in all things paranormal. With an Irish-Catholic upbringing, she is a fourth-generation Denver pioneer, and her history also includes a long matriarchal lineage of sensitive individuals. Valerie had fascinated us with stories of how her mother has been visited by the apparitions of family members who came to say goodbye immediately before dying, before anyone knew they had actually died. She kept us spellbound with tales of her experiences with poltergeists in haunted hotels. Valerie's paranormal "experience," combined with the fact that she respects the spiritual world while keeping her sense of humor about it, made her the perfect candidate to come along while I explored the house. I also knew that if I took Valerie along, interesting things would happen.

Valerie actually visited the mansion three times. During her first evening visit, it was snowing lightly, and as we approached the house and passed it to try to find a place to park, she saw a face peering out a second-floor window. She says now that when she first entered the grand foyer, she felt as though she was in a busy shopping mall. "It wasn't ominous at all, that first visit," Valerie said. "But it was heavy and very chaotic. I kept saying out loud: '*What* went on here?'"

As she toured the house, she felt the presence of several spirits, but just as other visitors had pointed out to us, none of them seemed connected. "They were whirling about and lost," she said. Her most notable impressions included music playing in an upstairs room and the sound of an elderly man breathing in the long, narrow bathroom on the second floor. At the end of that first visit, as Valerie and I sat together on the main stairway, a most curious thing happened. As we peered across the entry hall at our reflection in the huge mirror, a freezing cold presence came between us. It was frigid. It is difficult to explain, but the entity felt small in stature and it stayed until we stood up. It chilled Valerie's left side and my right side. That entry hall area was always "active," every time we were in the house. Just as Krista had

concluded during her visit to the mansion, Valerie considers the entry, and the freezing cold spot in front of the mirror, to be the heart of the house.

Valerie also tagged along with us during both paranormal investigations. Interested in seeing how these events were run, she talked to everyone on the scene and kept the mood light. During her second visit, her first impressions of the mansion were reaffirmed, but this time as she entered she felt as though the house was annoyed by the presence of all the people on the investigation team. "It was as though the house was just watching. It was just waiting and watching to see what would go on." On that second night, Valerie remarked how the house became noticeably colder the longer we stayed and that the rooms had more cold spots than usual.

The Spirit Paranormal Investigations team was in the mansion during Valerie's third night, and it was this visit that convinced her that she would never go into the house again. "Every time I visited, before entering, I would tell the house that I realized I was there as a guest and that I was respectful of the house," Valerie recalled. "On the third night, I realized after the fact that I had said this in a rushed, cavalier way. Maybe that was my mistake." In fact, no sooner had she arrived at the stairs leading up to the front door than she began to have trouble breathing. The higher she went in the house, up to the second and third floors, the harder it was for her to catch her breath. "I had a heavy feeling in my chest. The house was frenzied. It was unhappy, and I felt it would become threatening," she said. "We were the antagonists that night. The house wanted to push us out. It was on the defensive."

As she went from floor to floor with the psychics, she smelled tobacco smoke and again heard the music in one of the rooms. Finally, as she stood in the second-floor control room set up by the investigation team watching the TV monitors, her breathing became extremely labored, and she had to leave. The investigation team members were staging reenactments of a suicide, and she felt the house was becoming increasingly agitated. She walked down the half flight of stairs to the second landing, and at that point she froze. "Something in front of me stopped me in my tracks. It blocked my view of the stairs. It came to my throat. I stopped breathing." She doesn't remember getting down the rest of the stairs or how she ended up standing across the street, gasping for air.

Valerie has vowed to never enter the Croke-Patterson Mansion again. Now that her experiences are behind her, however, she has some clearer insight into what might be happening within its massive red sandstone walls. "There are all kinds of things going on there. It is extremely unsettled," she told me. "I feel as though the house draws certain types of people to it.

I went in keeping my empathetic self clear. I went in very analytical. But I have never had a physical experience like this. I have been emotionally affected, but never physically."

It took her three days to recover from the experience. With her body aching, and feeling very depressed, exhausted and completely drained after the last visit, she called to say her days at the mansion were over. "The true indicator was that my cats wouldn't come near me for several days after that last time. That says a lot." She had always been game to visit the mansion and had known nothing of its history beforehand. With this last terrifying incident, however, Valerie's interaction with the house was finished.

WHISPERS IN THE NIGHT

This visit to the Croke-Patterson Mansion would be the third trip to the house for Spirit Paranormal Investigations. Kevin Samprón, president of the company, was excited to bring his team back to the infamous mansion, where they had gathered evidence of paranormal activity before. He was even more excited to report to us that his findings might be enhanced due to a geomagnetic storm happening the same night, which would increase the amount of ambient energy in the environment. He explained that since paranormal activity is most likely closely linked to energy fields, the influx caused by the storm could increase the chance of capturing evidence. Kevin also felt that there would be an increased possibility of intelligent, or interactive, ghostly encounters. "The theory is that since the house has been vacant for so long, the spirits become lonely, curious or just plain angry that someone is in their personal space again, and therefore they act out," he explained. We were hooked.

We certainly weren't experts in paranormal investigations at this point, by any stretch of the imagination, but we knew a little more of what to expect. Like the team that had investigated the mansion a few weeks earlier, the Spirit crew entered with a bang. Vans pulled up with suitcases of equipment, and a college film crew captured the burst of activity, conducted interviews and generally added to the buzz. The team had its routine down, and the members followed the thorough setup plans they had sent us to the last detail. Each floor had a specific investigative plan, and each team member had a predetermined responsibility. This investigation was to last over six hours, from 9:15 p.m. through 3:30 a.m.

Kevin Samprón has been ghost hunting since 2003 and told us that he had formed Spirit Paranormal Investigations back in 2005 to meet the growing demand for such services. The team starts all formal investigations by looking for natural explanations first. If the activity is recorded and still no natural explanation is available, Kevin and his team step in to help validate the evidence. They come to every situation armed with a high level of training, attention to detail and professionalism. We certainly found that to be true during this investigation.

There was method to the madness on the night of their Croke-Patterson vigil. They set up their control center on the second floor and began to monitor the equipment. There were digital, true infrared and full-spectrum still cameras, as well as digital, night vision and full-spectrum video cameras. There were audio and video monitoring systems, digital voice recorders and even laser grids. Thermometers, a thermal imaging camera and motion detectors were placed around the house. In addition to several EMF detectors, the team also set up an EMF pump—used to produce an artificial surge in electromagnetic field—on the theory that a highly active EMF will "attract" ghosts by providing the entities with the energy they need to manifest visibly. The environmental conditions were carefully noted, right down to the phase of the moon ("first quarter, 53% of full"). Last but not least, Spirit included the talents of two sensitives on their team: Kate, who'd already had a profound experience in the mansion, and Kim, who was about to have one of her own. The group was ready to go.

To our amazement, there was even more to the production: two reenactments were staged to try to draw out spirit reactions. The first, held in the former nursery on the third floor, was an imaginative re-creation of the Tulleen Sudan suicide, based on mansion folklore. The second was a reenactment of the female spirit descending the main stairway, a common sighting according to those we had interviewed. Lastly, based on the suspicion that Senator Patterson is the predominant male spirit in the home, excerpts of the final edition of the *Rocky Mountain News*—the paper Patterson owned and which folded February 27, 2009—were read aloud. Spirit had all the bases covered.

During Spirit's last investigation of the mansion, in February 2005, the team hit the mother lode when a member of the crew experienced a rare physical interaction: a tap on the shoulder. That investigation was also the scene of an apparition. Dan witnessed a featureless head leaning over the banister near the bottom of the main stairway. They also picked up a woman's voice on an EVP (electronic voice phenomenon) recording that

clearly says, "One thousand." That recording came from the third-floor nursery room.

This time, as during their first two visits, Kevin was most concerned about ambient noise pollution. "Our game plan during this investigation was to focus on this third-floor area of the building, as well as canvass the mansion with audio recording devices, in hopes that we could triangulate sounds and rule out most of the external noises." Kevin went on to say:

> *Our greatest fear, however, was that the frequent external noise pollution would simply wash out the majority of any paranormal recordings, thereby reducing our chances to confirm paranormal phenomenon. Because of the mansion's proximity to Denver's Capitol Hill nightlife, audio pollution was the chief concern for us.*

For six hours, the crew monitored data, while small teams of individuals investigated the mansion, room by room. Their final report was interesting, to say the least. Despite the abundance of cameras on site, nothing of note

The Spirit Paranormal Investigations team collects data during its investigation in the mansion. *Left to right*: investigator Kathy Samprón, research manager Kendra Alder and Spirit president Kevin Samprón. *Photo by Ann Alexander Leggett, March 2011.*

was captured through any means of photography. EMF readings remained mostly steady, with moments of unstable interactions in certain locations. The most likely cause of the instability was noted as old wiring in the house. Thermal readings were stable, and nothing was captured on video. The audio evidence, however, was quite another story.

At approximately 1:28 a.m., Team A (consisting of two females and one male) was investigating the main floor when a secondary recorder in the room picked up a voice. "Who's that girl?" the male voice asks. At the same time, as they walked through the main level, a recorder on the third floor picked up the clear sound of a desk drawer or closet door rolling open and closing—twice. Triangulation of audio equipment points directly to the third-floor southeast bedroom, where one of the previous owners had reported watching locked desk drawers open and close by themselves and a closet doorknob turn on its own.

At 1:44 a.m., as Team A moved on to investigate the basement, two voices were captured, again in the southeast third-floor bedroom. "No," says a low, male voice, very similar to the voice heard by the team just minutes earlier on the main floor. A few seconds later another, evil-sounding male voice says, "Yessssssss." Recording devices set up in the southeast bedroom on the third floor picked up one more voice. At approximately 2:10 a.m., a whispery male voice can be heard saying what sounds like "tonight," followed by another couple of words that are unintelligible. Spooky, indeed.

Plenty of sounds were picked up by the team that night, but it takes skill to separate and sift through the layers of audio. "Through a grid of audio recording devices placed strategically throughout the mansion, a distinctly controlled environment and a highly-trained investigative staff, we were able to triangulate sounds down to specific rooms and locations," Kevin said. "This helped us debunk the outside noise pollution and confirm the high accuracy the EVPs presented, which we believe came from inside the mansion."

Electronic Voice Phenomenon is defined by Kevin as "subsonic sounds that have been imprinted onto sensitive audio recording devices through means not yet understood. These sounds are not heard (by human ears) during the time of the recording but appear upon analysis of the electronic audio file. Disembodied voices are spirit voices that are heard with the human ear and can be recorded on audio devices." Although the use of EVP monitors in paranormal investigations is not without controversy—some believe their use reveals a predisposition to find ghosts—the equipment itself is quite impressive, as are the results.

The sounds are recorded in their raw form on a variety of recording devices. Through the use of an Adobe sound program called Audition, Kevin makes the sounds clearer by tweaking the levels of the audio. He runs a bass or treble booster, based on how the voice sounds, and he also filters the noise in various stages. Every room, according to Kevin, has a base voice of its own: a sort of low, dull white noise, even when there is no outside interference. He samples the room noise and creates a filter, which he then applies to the audio clip, pulling the room's "voice" off the audio and cleaning it up a little more. Noise and hiss reducers are also applied, until much of the surrounding interference is eliminated and the EVP is made as clear as possible.

EVPs are classified according to clarity and strength. Class A EVPs are the most distinct and sound as clear as people speaking to each other in the same room. They may require some light filtering to be understood completely, but they are typically very clear. Class B EVPs are less distinct, but audible, and may require more intensive filtering to discern the words spoken. Finally, the C Class recordings are made up of indistinct voices that need to be filtered extensively, and not all the words will end up intelligible. The majority of the EVPs captured by Spirit on this night would be categorized as Class B or C, but a few of the vocalizations were chillingly distinct.

The two sensitives on the team, Kate and Kim, were deeply affected by their time in the house that night. Kate, still unnerved by her previous experiences, sensed the dark male energy in the mansion, particularly in the basement. Kim felt it as well, and both sensitives also strongly felt the presence of a submissive woman. These two spirits are definitely part of the folklore of the mansion and have been sensed or witnessed by others we interviewed during our research. But Kim also had a physical encounter that night. At about 2:00 a.m., as she was walking up the stairs from the basement, something yanked forcefully on her left shoulder, pulling her down two full stair steps. Despite being rattled by the experience, she believes it was the submissive female trying to communicate. Kim also felt as though she were continually being followed throughout the night, prompting Kevin to conclude that her encounter "matches an EVP we captured in the same room, of that dominant male figure saying the words, 'Who's that girl?'"

"The mansion is indeed haunted," Kevin reports. "We believe this as a result of the combination of confirmed audio evidence involving several suspected EVPs, a disembodied voice, the sound of furniture moving and the strong personal experiences of the team sensitives."

The team concluded its analysis by ranking the haunting as intelligent, as opposed to residual. Residual hauntings are, according to Kevin, almost like recordings in that they are non-interactive phenomena that are played back by the environment, such as "a woman in white walking down the stairs every November 1." These hauntings "neither see nor hear us," and they continue to do what they may have done for many years. Intelligent hauntings, on the other hand, interact with investigators, changing or responding when presented with scenarios, objects or questions. Based on the EVPs and other audio recorded by the team that night, the label of an intelligent haunting seemed to fit well with the experiences described to us by others and with what we had encountered ourselves in the time we spent in the house. It appears that interactive spirits may still make themselves at home in the Croke-Patterson Mansion.

A LONELY HOUSE NO MORE

Believe it or not, this story has a happy ending. At the time this manuscript was being delivered to the publisher, new owners were working feverishly to turn the old place into a bed-and-breakfast. The deteriorating stone was being refurbished and repaired, the interiors brought back to their original glory—as much as is possible—and the grounds replenished with new, lush landscaping. The mansion will shine again as one of Denver's finest, the way it did when Thomas Croke had it built 120 years ago.

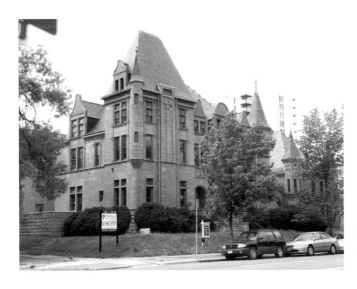

The Croke-Patterson Mansion in May 2011. *Photo by Ann Alexander Leggett.*

For the first time in its history, the mansion will be available for the public to see and enjoy. Some will find the house quiet and charming, while others will leave after a night's stay with new spooky tales of their own, adding to the folklore that will forever be part of the building's history.

We are thankful, even as outside observers who were able to be a part of the "life" of this house for just a short time, for organizations like Historic Denver for their preservation work, for people like Mary Rae for saving it from being demolished and for the new owners who are bringing the building back to life and allowing the public to finally peek inside its doors.

The Croke-Patterson Mansion will once again thrive with activity, some of it from the guests who will certainly enjoy their stay at such a historic and purportedly haunted hotel, and from those who still roam the hallways in search of the peace that has eluded them for so many years.

Appendix

BUILDING FLOOR PLANS

Page 132: The basement.

Page 133: The main level.

Page 134: The second level.

Page 135: The third level.

Drawings courtesy of RAW Architecture, 2011.

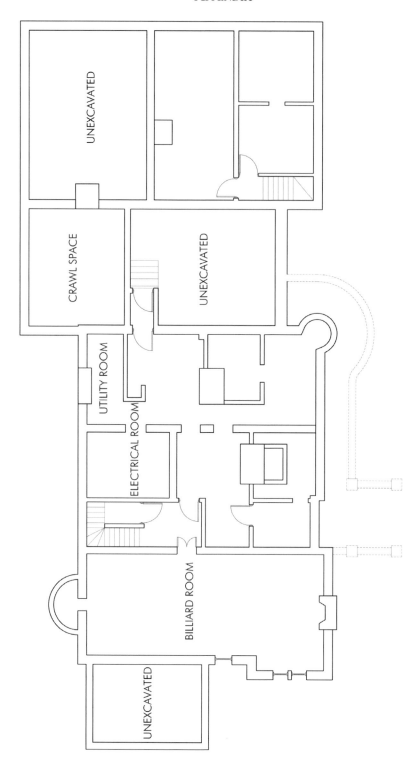

LOWER LEVEL FLOOR PLAN

Building Floor Plans

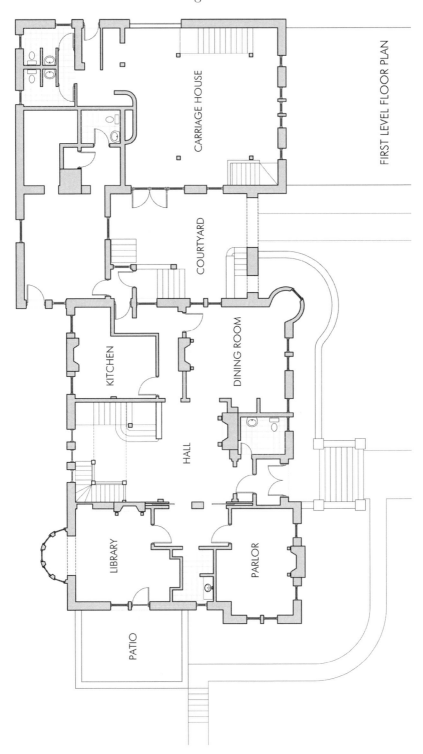

FIRST LEVEL FLOOR PLAN

CARRIAGE HOUSE

COURTYARD

KITCHEN

DINING ROOM

HALL

LIBRARY

PARLOR

PATIO

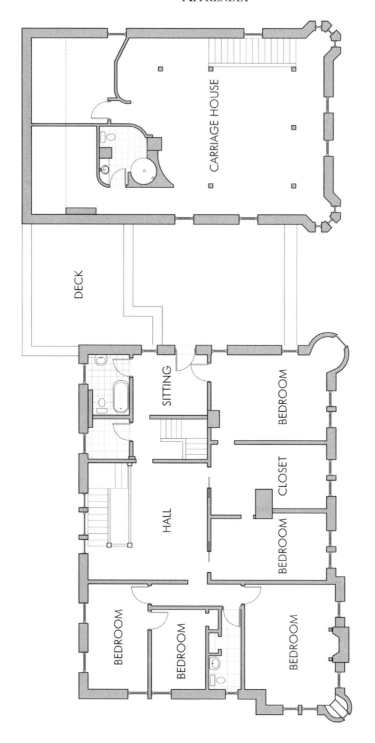

SECOND LEVEL FLOOR PLAN

CARRIAGE HOUSE

DECK

SITTING

HALL

BEDROOM

CLOSET

BEDROOM

BEDROOM

BEDROOM

BEDROOM

BEDROOM

Building Floor Plans

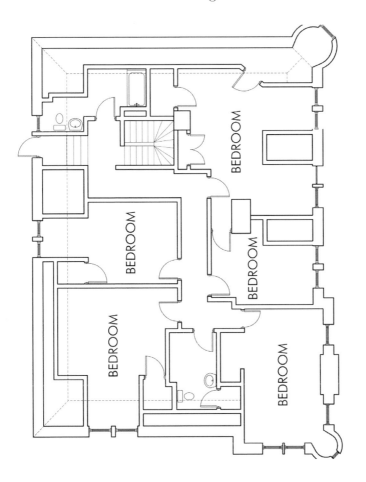

BEDROOM

BEDROOM

BEDROOM

BEDROOM

BEDROOM

BEDROOM

BIBLIOGRAPHY

BOOKS

Bretz, Jim. *Mansions of Denver, The Vintage Years: 1870–1938*. N.p.: Pruett Publishing, 2005.

"A Chapter of Denver's History." In *Magazine of Western History, Volume X*. New York: Magazine of Western History Publishing Company, 1889.

Davis, Sally, and Betty Baldwin. *Denver Dwellings and Descendants*. Denver, CO: Sage Books, 1963.

Downing, Sybil, and Robert E. Smith. *Tom Patterson: Colorado Crusader for Change*. Denver: Press of Colorado, 1995.

Goodstein, Phil. *Ghosts of Denver: Capitol Hill*. Denver, CO: New Social Publications, 1996.

Grinstead, Leigh A. *Molly Brown's Capitol Hill Neighborhood*. Denver, CO: Historic Denver Guides, 2002.

Hall, Frank. *History of the State of Colorado*. Chicago: Blakely Printing Company, 1889.

Kalman, Harold. "Styles and Movements in Western Art, 1400–1900." In *Grove Dictionary of Art: From Renaissance to Impressionism*. Edited by Jane Turner. New York: St. Martin's Press, 2000.

Murphy, Jack A. *Geology Tour of Denver's Capitol Hill Stone Buildings*. Denver, CO: Historic Denver Guides, 1997.

Pearson, Michelle. *Historic Denver Landmarks for Children and Families*. Denver, CO: Historic Denver Guides, 2007.

Representative Men of Colorado in the Nineteenth Century. New York: Rowell Art Publishing, Denver, 1902.

Twelfth Biennial Report of the Board of Capitol Managers to the General Assembly of the State of Colorado. Denver, CO: The Smith Books Printing Co., State Printers, 1906.

Vaughn, Stephen L., ed. *Encyclopedia of American Journalism.* New York: Taylor & Francis Group, 2008.

Articles/Periodicals

Downing, Sybil. "Six of the Greatest: Thomas Patterson." *Colorado Lawyer* 31, no. 7 (July 2002). Available online at http://www.cobar.org/tcl/tcl_articles.cfm?ArticleID=1760.

Edwards, Evan. "Mountain Medicine Man." In *Rocky Mountain Empire.* Edited by Elvon L. Howe. Garden City, NY: Doubleday & Co., Inc., 1948. Available online at http://www.archive.org/stream/rockymountainemp006249mbp/rockymountainemp006249mbp_djvu.txt.

Foster, Nancy. "A Castle on the Hill." *Life on Capitol Hill News,* February 2011.

Kohl, Edith Eudora. "The House of Croke." *Denver Post,* September 12, 1948.

Lehndorff, Betsy. "Jitterbugs." *Rocky Mountain News,* October 28, 2000.

Mitchell, Barbara. "History—Dr. Archer Sudan, MD: Doctoring in Middle Park from 1926 to 1947." *Sky-Hi News,* January 19, 2009. Available online at http://www.skyhidailynews.com/article/20090119/NEWS/901199972.

Time. "Medicine: Family Doctor." January 19, 1948. Available online at http://www.time.com/time/magazine/article/0,9171,779569,00.html.

Waters, Jeff. "Denver's Magnificent Mansions—Tales of Love, Tragedy and Power." MyTownCryer.com. http://mytowncryer.com/my-townsnews/denver-real-estate-news.

Zimmer, Amy. "A Stronghold of the 'Smart Set.'" *Colorado Heritage,* Spring 2005.

COLLECTIONS/FILES

Bratigan, Charles O., ed. *The Denver Building Permits File*. Vols. 2, 3 and 4, 1889–1905. Denver Public Library, Denver, CO.

City of Denver Building Permit Files (up to 1889–1905).

Croke-Patterson Mansion Files. Historic Denver, Denver, CO.

National Registry of Historic Places Inventory/Nomination Form. United States Department of the Interior, National Park Service, 1973.

University of Colorado at Boulder, University Archives. Thomas Patterson Collection.

ON-LINE RESOURCES

Ancestry.com. http://www.ancestry.com.

Archives.com. http://www.archives.com.

Big Map Blog. http://www.bigmapblog.com.

City of Cincinnati Historical Preservation and Research Resources. "Richardson Romanesque 1880–1900." http://www.cincinnati-oh.gov/cdap/pages/-3781-.

Colorado Department of Personnel & Administration. "Colorado State Archives." http://www.colorado.gov/dpa/doit/archives/hrd/index.htm.

Colorado Genealogy Trails. "Biographies of Citizens of Denver County Colorado: Humphrey Barker Chamberlin." http://genealogytrails.com/colo/denver/bio.html#HUMPHREY_BARKER_CHAMBERLIN.

Denver Public Library. "Creating Communities: Capitol Hill." http://creatingcommunities.denverlibrary.org/content/capitol-hill-story.

Denver Water. "Historical Timeline." http://www.denverwater.org/AboutUs/History/historicaltimeline.

Friends of Red Rock Canyon. "Red Rock Canon Stone in Denver's Historic Buildings." http://www.redrockcanyonopenspace.org/page66.html.

The Greenway Team, Inc. "Croke Reservoir." http://greenwayteam.com/?p=211.

Hearthstone Legacy Publications. "When the Skies Turned to Black: The Locust Plague of 1875." http://www.hearthstonelegacy.com/when-the-skies-turned-to-black-the_locust-plague-of-1875.htm.

History Colorado. "Irrigation and Water Supply Ditches and Canals in Colorado." http://www.historycolorado.org/sites/default/files/files/OAHP/crforms_edumat/pdfs/DitchesMPDFdraft.pdf.

Legends of America. "Haunted Cheesman Park in Denver, Colorado." http://www.legendsofamerica.com/co-cheesmanpark.html.

Life on Capitol Hill. "A Castle on the Hill." http://www.lifeoncaphill.com/index2.php?option=com_content&task=view&id=1364&pop=1&page=0&Itemid=66.

Prairieghosts.com. "Ghosts of Cheesman Park." http://www.prairieghosts.com/cheesman.html.

Rocky Mountain Paranormal Research Society. "Cheesman Park Cemetery." http://www.rockymountainparanormal.com/Cheese.htm.

Ross, Benjamin L. "Works of Isaac Hodgson, Architect." http://b-levi.com/research/arch/hodgson/index.php.

Softsquatch.com. "10 Scariest Haunted Houses in America." http://www.softsquatch.com/blog/10-scariest-haunted-houses-america.

Strange USA. "Haunt in Croke-Patterson-Campbell Mansion 428-430 E. 11th Ave Denver, CO 80202." http://www.strangeusa.com/ViewLocation.aspx?locationid=12071.

Suite101.com. "Ghosts of Haunted Cheesman Park." http://www.suite101.com/content/ghosts-of-haunted-cheesman-parka324306?template=article_print.cfm.

United States Mine Rescue Association. "Colorado Mining Disasters." http://www.usmra.com/barrick/colorado.htm.

Waymarking.com. "Croke-Patterson-Campbell Mansion - Denver, Colorado." http://www.waymarking.com/waymarks/WM7YMK_Croke_Patterson_Campbell_Mansion_Denver_Colorado.

Waymarking.com. "FIRST- Gold Discovered in Colorado." http://www.waymarking.com/waymarks/WMVFM_FIRST_Gold_Discovered_in_Colorado_Denver_CO.

Westmoreland County Genealogy Project. "William Larimer Jr." http://www.pa-roots.com/westmoreland/historyproject/vol1/chapter46larimer.html.

Wikipedia.com. http://www.wikipedia.com.

ABOUT THE AUTHORS

Authors Jordan Alexander Leggett (left) and Ann Alexander Leggett outside the Croke-Patterson Mansion. *Photo by Nicholas Cutler Leggett.*

Author, public relations specialist, designer and artist—these are just a few of the many hats worn by Ann Alexander Leggett. Her love of history and ghosts, however, has found its way into several of her projects and seems to have become a major part of her life. It can be a crazy day when switching gears from meeting about a major concrete construction project to lurking around haunted houses and cemeteries, but she balances it all—happily. Ghostly things that go bump in the night fascinate her, and she has apparently passed this attraction to the spirit world along to her daughter, who is coauthor of this latest book. Ann attended the University of Colorado, graduating with a degree in journalism, and has lived in the Boulder area ever since. She is the coauthor of two other historically-based ghost books: *Haunted Boulder* and *Haunted Boulder 2*.

Born and raised in Boulder, Colorado, Jordan Alexander Leggett now spends most of her time in Seattle amidst a tumultuous relationship with

the University of Washington. She is pursuing a major in English literature with a minor in classics, and she is currently plotting a contingency plan that doesn't involve living with her parents until she is gainfully employed and in her mid-thirties. Odd part-time customer service jobs are her specialty, and when she isn't working at a gym making protein shakes, she reads and re-reads such classics as *Bleak House* and *Winnie the Pooh*. Following in her mother's footsteps, she also devotes free time to other forms of art, as well as various blood sports such as rugby. She plans on spending quite some time in Seattle, her home away from home, but Colorado will always have a piece of her heart.

Visit us at
www.historypress.net